IMAGES
of America

MARITIME MANITOWOC
1847–1947

On the cover: The newly built *Alabama* and *Virginia* owned by the Goodrich Lines sit stern-to-stern alongside Berth B at the Manitowoc Shipbuilding Company. The *Alabama* was launched in 1909 at the Manitowoc Shipyards. The *Virginia* was launched in 1891 at the Globe Iron Works in Cleveland, Ohio.

IMAGES
of America

MARITIME MANITOWOC
1847–1947

Wisconsin Maritime Museum

ARCADIA

Copyright © 2006 by Wisconsin Maritime Museum
ISBN 0-7385-4002-1

Published by Arcadia Publishing
Charleston SC, Chicago IL, Portsmouth NH, San Francisco CA

Printed in the United States of America

Library of Congress Catalog Card Number: 2006920997

For all general information contact Arcadia Publishing at:
Telephone 843-853-2070
Fax 843-853-0044
E-mail sales@arcadiapublishing.com
For customer service and orders:
Toll-Free 1-888-313-2665

Visit us on the Internet at http://www.arcadiapublishing.com

CONTENTS

ACKNOWLEDGMENTS

The following crew, all staff or volunteer members at the Wisconsin Maritime Museum, were instrumental in the creation of this book. Larry Bohn, a resident of Manitowoc since the 1950s, has been working as a volunteer at the Wisconsin Maritime Museum since 1971. He taught Industrial Arts in the Manitowoc Public Schools until 1994, and he was instrumental in restoring the museum's operational steam engine exhibit.

Dale Fischer was born and raised in Manitowoc and comes from a family of sailors. During most of his career, Dale worked as a chief engineer on Great Lakes and Inland River System boats. Dale has worked as a volunteer at the Wisconsin Maritime Museum since 2003.

Bob Peppard, a Manitowoc native who in 1968 helped establish the Manitowoc Submarine Association Museum, now the Wisconsin Maritime Museum, proudly served much of his career as a second engineer in the U.S. Army Corps of Engineers. He now spends much of his time researching maritime history at the museum.

Bob's brother Charles Peppard is also a dedicated volunteer at the Wisconsin Maritime Museum. He has enjoyed a career working in the Manitowoc Company's Crane Division.

Douglas C. Koch is a lifelong resident of Manitowoc and recently retired from the newspaper publishing field. He served on the Wisconsin Maritime Museum Board of Trustees for nine years and was president of the museum's board for three years. Presently he volunteers and performs research in the museum's library. Some of that research work can be seen in this book.

Art Chavez has written extensively on the maritime history of the Great Lakes, including two other books for Arcadia Publishing.

Johanna Vance has been working for the Wisconsin Maritime Museum since 2004 as a tour guide and for the USS *Cobia* Overnight Education Program. She became a member of the book team to help coordinate the project.

William Thiesen is director of operations and curator of the Wisconsin Maritime Museum, where he has served since 2001.

INTRODUCTION

Captain Carus's interest in ships and shipbuilding was his life's work as well as his hobby. He was an avid photographer and collector. His albums number 27 and contain over 3,000 photographs and manuscripts. With the help of his friend Edwin Schuette of Manitowoc, who was also a marine enthusiast, they expanded both of their collections. In 1937, Carus's wife became ill and he could no longer invest the time that was needed to maintain his portion of the collection. Henry Barkhausen, then of Chicago, purchased Carus's collection. Schuette's portion of the collection was handed down to his son Henry Schuette. In 1980, Henry Schuette and Henry Barkhausen donated the entire Captain Carus collection to the Wisconsin Maritime Museum. Many of the photographs in this book are reprints from the Carus Collection. Copies of any of the photographs in this book may be obtained by contacting the Wisconsin Maritime Museum, 75 Maritime Drive, Manitowoc, Wisconsin 54220, attention Archives Department. Be sure to include the accession number shown at the end of each photograph caption.

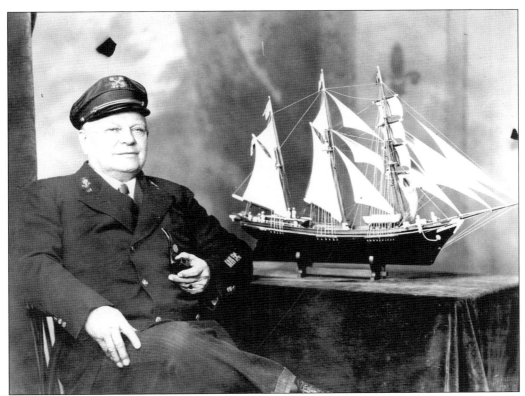

Capt. Ed Carus (1860-1947) began his 56-year sailing career on the Great Lakes in 1874. In 1882, Carus received his master's license and command of his first ship, the *George A. Marsh*. In 1915, after sailing for several shipping companies, Carus was employed by the Manitowoc Shipbuilding Company as an employment agent. In addition to his responsibilities as employment agent, he also sailed many of the Manitowoc-built cargo ships to the Atlantic Coast. He retired from the Manitowoc Shipbuilding Company in 1930. (P82-37-7-1.)

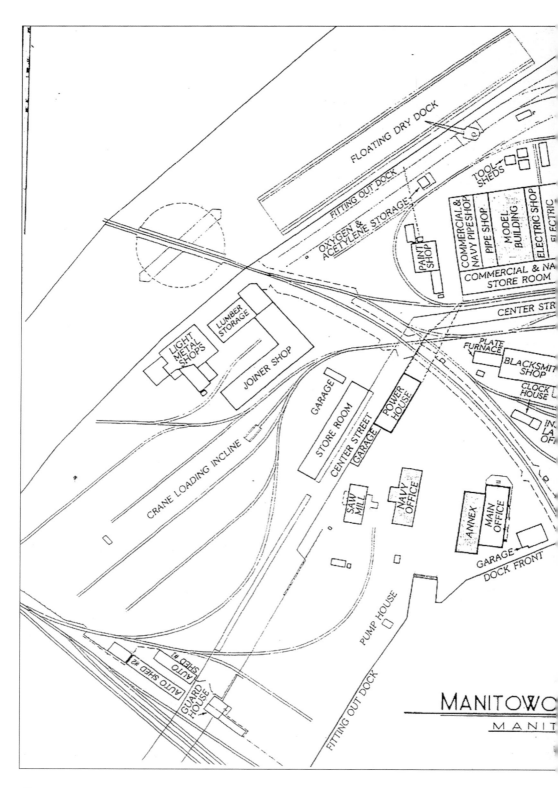

FLOATING DRY DOCK

FITTING OUT DOCK

OXYGEN & ACETYLENE STORAGE

TOOL SHEDS

PAINT SHOP

COMMERCIAL & NAVY PIPESHOP

PIPE SHOP

MODEL BUILDING

ELECTRIC SHOP

ELECTRIC

COMMERCIAL & NA STORE ROOM

CENTER STR

PLATE FURNACE

BLACKSMITH SHOP

CLOCK HOUSE

LIGHT METAL SHOPS

LUMBER STORAGE

JOINER SHOP

GARAGE

STORE ROOM

CENTER STREET GARAGE

POWER HOUSE

CRANE LOADING INCLINE

SAW MILL

NAVY OFFICE

ANNEX

MAIN OFFICE

GARAGE

DOCK FRONT

PUMP HOUSE

AUTO SHED #2

AUTO SHED #1

GUARD HOUSE

FITTING OUT DOCK

MANITOWO

MANIT

8

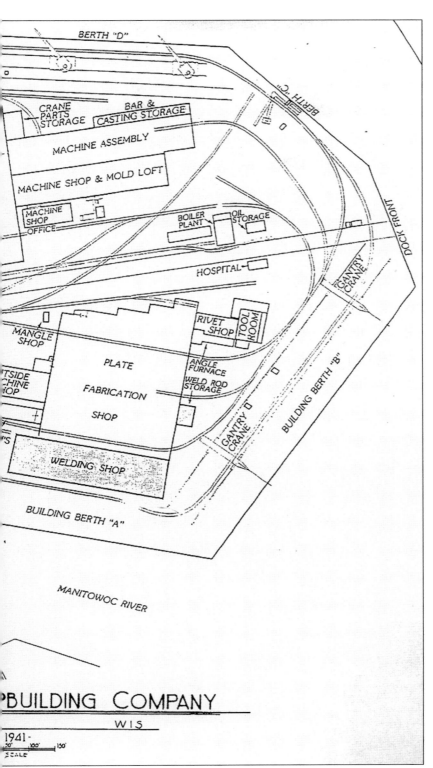

BERTH "D"

CRANE PARTS STORAGE

BAR & CASTING STORAGE

MACHINE ASSEMBLY

MACHINE SHOP & MOLD LOFT

MACHINE SHOP OFFICE

BOILER PLANT

OIL STORAGE

BERTH "C"

HOSPITAL

DOCK FRONT

GANTRY CRANE

MANGLE SHOP

RIVET SHOP

TOOL ROOM

PLATE

FABRICATION

SHOP

ANGLE FURNACE

WELD ROD STORAGE

TSIDE CHINE OP

GANTRY CRANE

BUILDING BERTH "B"

WELDING SHOP

BUILDING BERTH "A"

MANITOWOC RIVER

BUILDING COMPANY

WIS

1941-

SCALE 50' 100' 150'

This 1941 map of Lueps Island, later known as "the Peninsula," was perhaps a forerunner of what is now an industrial park. Lueps Island eventually became home to the Burger Boat Yard as well as the Manitowoc Shipbuilding Company. This map compares with the lower photograph on the next page, showing the same scene from a different angle.

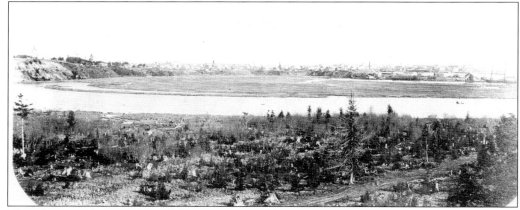

This photograph was taken of the same area as the photograph below, well before the time of any of the shipyards. Various types of schooners, steamers, pleasure yachts, and military craft (including 28 World War II submarines) were built on the Peninsula. Having built over 400 vessels over a 70-year period at this location, the Manitowoc Shipbuilding Company moved its marine operation in 1968 to Sturgeon Bay, Wisconsin. (P82-37-2-109.)

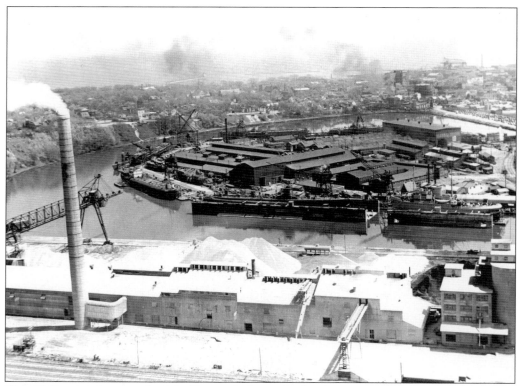

This 1943 aerial photograph of the Peninsula shows the development of Lueps Island as shown in the photograph above. Viewed from the northwest, the Manitowoc Portland Cement Company may be seen in the foreground. (P95-8-8.)

One

EARLY MANITOWOC-BUILT VESSELS

Manitowoc had its beginning as a shipbuilding center in 1847, when Capt. Joseph Edwards built a three-masted schooner called the *Citizen*. Schooners as well as other types of sailing vessels played an important roll in the development of Manitowoc, as well as other ports on the Great Lakes. It was reported that by 1860 there were 1,855 sailing vessels on the Great Lakes.

In addition to Edwards, there were many other early pioneering shipbuilders in Manitowoc, such as William Bates, Elias Sorenson, Henry and George Burger, Jonah Richards, Greenleaf Rand, Jasper Hanson, Peter Larson, Mads Omes, Gunder Jorgenson, and Capt. Francis P. Williams. One of the most famous and influential schooner builders at that time was William Bates. Bates designed and built a faster and more slender schooner similar to the trim China Clippers. Thus Manitowoc became known as the "Clipper City." The last schooner to be built on the Great Lakes was built in Manitowoc. It was a three-masted schooner called *Cora A.* built by Burger and Burger in 1889.

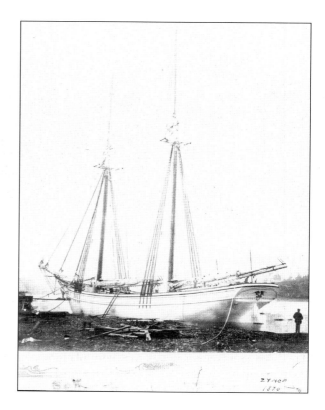

This 1870 photograph shows the Manitowoc schooner *C. L. Johnston*, which was built by Manitowoc's E. W. Packard Shipyard. (P82-37-8-91.)

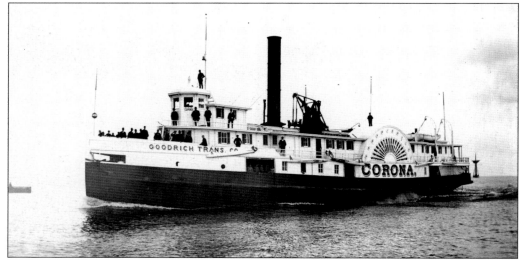

The *Corona* was built at the G. S. Rand Shipyard in Manitowoc between 1869 and 1870. It was built for Manitowoc's Goodrich Transportation Lines at a cost of $42,000. The *Corona* was the first Goodrich boat built for service on the eastern shore of Lake Michigan. In 1892, it was sold to John W. Warde of Chicago for $7,500. The boat was later used as an excursion steamer on Lake Erie. In 1898, it was destroyed in a fire while at the dock in Tonawanda, New York. (P82-7-6.)

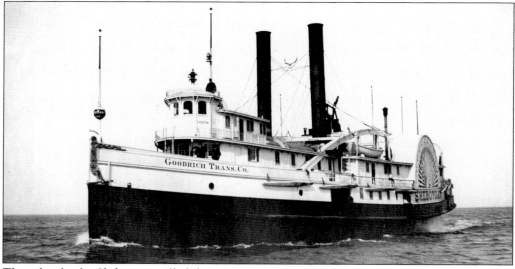

The side-wheeler *Sheboygan*, called the "Queen of Lake Michigan," was owned by the Goodrich Lines and built by G. S. Rand in 1869. The Rand Yard was located on the north side of the river above the Tenth Street Bridge. This area later became Wisconsin Central Railroad's warehouses and carferry docks. This photograph was taken before 1890, as Goodrich had changed the color scheme of its boats to all black hull and paddle boxes at that time. The elk horns mounted between the stacks and the American Indian brave atop the walking beam indicate that the *Sheboygan* had won certain races held between passenger steamers. After a long and successful life, the side-wheeler was scrapped in 1914 by running it aground and burning it along the Manitowoc River. (P82-37-7-118.)

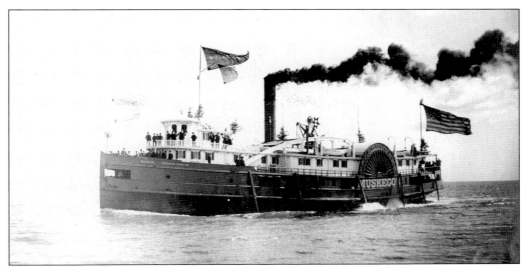

The Goodrich side-wheeler *Muskegon* is underway all decked out in evergreen branches, which were common decorations on Great Lakes steamers in November and December. The *Muskegon* was a popular passenger vessel in the late 1800s. The boat is bearing its new Goodrich color scheme, adopted in 1890, with a black hull and paddle boxes. A heavy plume of black smoke can also be seen. The *Muskegon* was destroyed in 1896, when its support blocking gave way in a Milwaukee dry dock. (P82-37-7-10.)

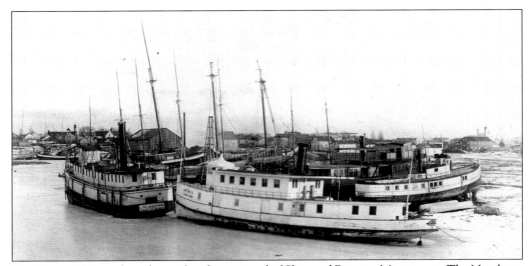

The Larson Shipyard was located at the west end of Shipyard Point in Manitowoc. The Northern Grain Elevator A would later occupy this location. The three closest vessels in this photograph are the *St. Maries*, the *Lotus*, and the *Dayan*. (P82-37-7-38.)

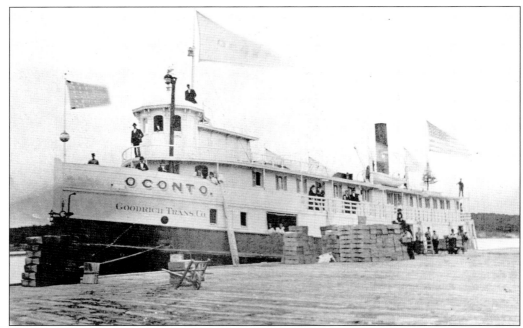

The 505-ton Goodrich steamer *Oconto* was built by Manitowoc's G. S. Rand Shipyard in 1872 at a cost of $42,204. Stacks of cedar shingle bundles are waiting to be loaded aboard the vessel. The *Oconto* became an institution and household word among the west shore ports of Lake Michigan that it served for many years. It was sold in 1883 for $13,500. (P82-37-7-45.)

The 796-ton Goodrich Lines package freighter *Menominee* was built by Manitowoc's G. S. Rand in 1872. A year later, the passenger cabin was added. The boat ran for many seasons on the Cross-Lake Route serving Muskegon and Grand Haven, Michigan, as well as Chicago. In 1896, it was dismantled and the hull and machinery provided the basis for construction of the ill-fated Great Lakes steamer *Iowa*. (P82-37-7-144.)

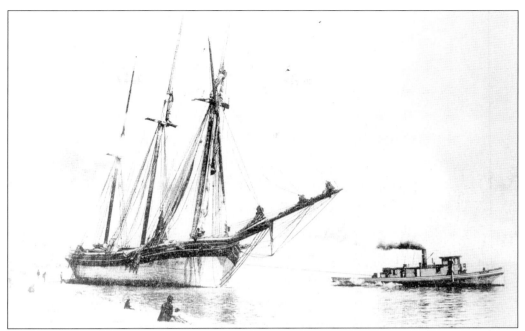

The schooner *C. C. Barnes*, which was built by Manitowoc's H. Burger Shipyard in 1873 is shown after running aground south of Milwaukee Harbor in May 1894. The tug *Carl* is attempting to pull this 582-ton schooner free. (P82-37-2-22.)

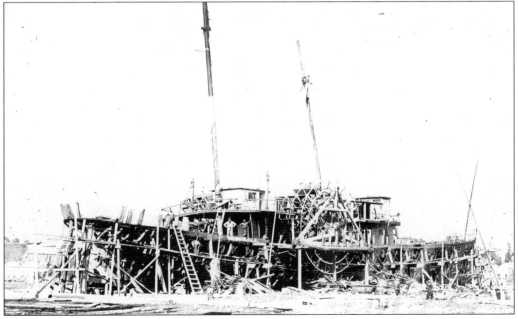

The U.S. Revenue cutter *Andrew Johnson* is being rebuilt in this 1881 photograph. The photograph was taken near the Eighth Street Bridge on the Manitowoc River's south bank in Manitowoc. (P82-37-7-54.)

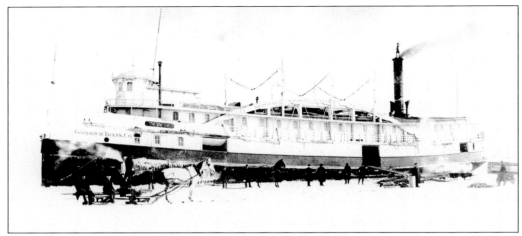

The propeller *De Pere* was built by Manitowoc's G. S. Rand Shipyard in 1873 for the Goodrich Line. The *De Pere* is pictured here in 1885 unloading passengers and package freight onto the lake ice just off the coast from Manitowoc. The vessel was a popular steamer in Milwaukee because it offered moonlight cruises on Lake Michigan. In 1891, it was sold to the firm of D. S. B. Grummond in Detroit. (P82-37-9-16.)

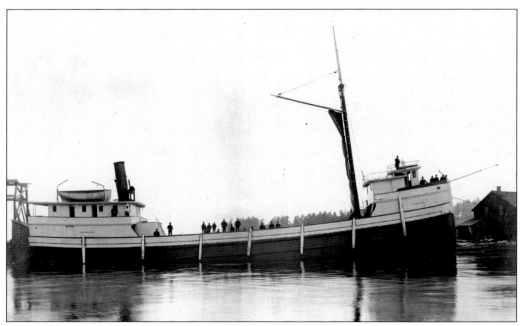

The 304-ton lumber hooker *A .D. Hayward* was built by Burger and Burger of Manitowoc in 1887. (P82-37-7-152.)

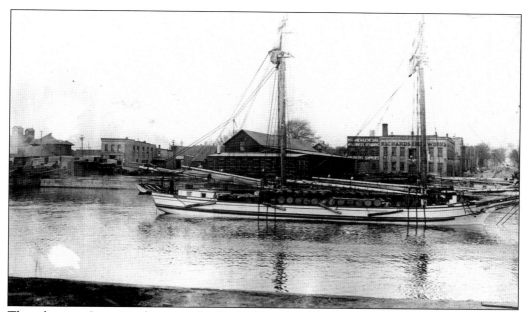

The schooner *Oscar Newhouse*, with a load of barrels of vinegar, is tied up at the foot of north Ninth Street in Manitowoc. In 1915, it was fitted with an auxiliary gasoline engine that enabled it to continue operation as a lumber hooker until it burned on the St. Mary's River in 1927. In its final days, during Prohibition, it was used to run liquor from Canadian ports to the United States. (P82-37-4-15.)

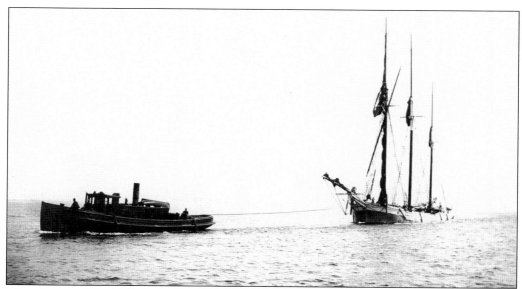

The schooner *Harvey C. Richards* was built by the Burger Shipyard in Manitowoc in 1873. It is shown being towed into port by the Goodrich tug *Arctic*, which was built by Manitowoc's G. S. Rand Shipyard in 1881. (P82-37-9-62.)

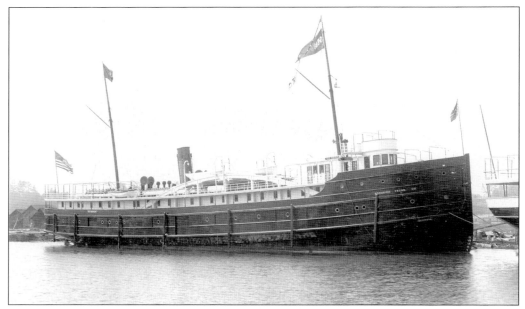

The 842-ton steamer *City of Ludington* was built by Manitowoc's G. S. Rand in 1881, at a cost of $60,000. It was designed for year-around service on the Cross-Lake Route between Ludington, Michigan, and Milwaukee. The vessel was one of the first steamers on the Great Lakes to be lit by electricity. It was rebuilt and lengthened in 1898 and renamed *Georgia*. The flag flying on its stern dates this photograph between the vessel's 1898 conversion and 1907. (P82-37-129.)

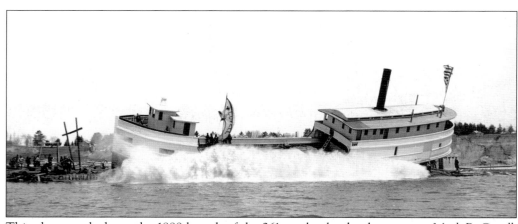

This photograph shows the 1888 launch of the 261-ton lumber hooker steamer *Mark B. Covell*. It was built by Burger and Burger in Manitowoc and rebuilt in 1909. In 1936, it returned to Manitowoc to be scrapped and burned. (P82-37-7-9.)

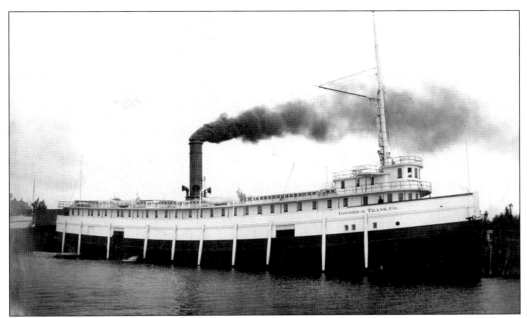

The Goodrich steamer *Racine* was built by H. B. and G. B. Burger at Manitowoc in 1889, at a cost of $125,000. This photograph shows it leaving for trials in June 1889. It was a splendid example of ship styling at the time. In 1909, it was rebuilt and renamed the *Arizona*, and at the end of its career it was left to rot away. (P82-37-7-12.)

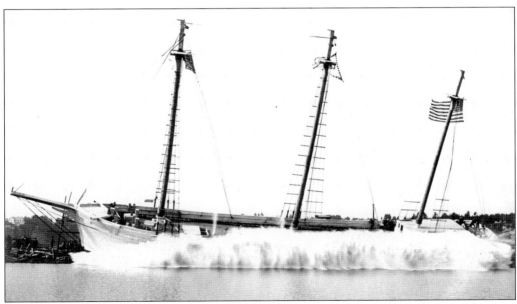

The launching of the schooner *Cora A.* took place in 1889 in Manitowoc. Burger and Burger built the *Cora A.* for the Chicago Transportation Company, and it was among the last schooners to be built on the Great Lakes. It worked on the Great Lakes until 1913, when it began working on the East Coast. The schooner sank in a storm off of North Carolina's Cape Hatteras in 1916. (P82-37-7-136.)

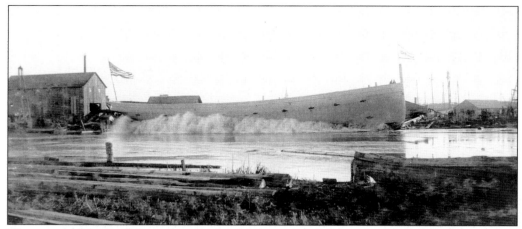

The steamer *John E. Hall* was launched at Manitowoc in 1890 at the Samuel Hall Shipyard. It was originally built for Timothy Donovan, and it sank on Lake Ontario in 1902 with a loss of nine lives. (P82-37-7-85.)

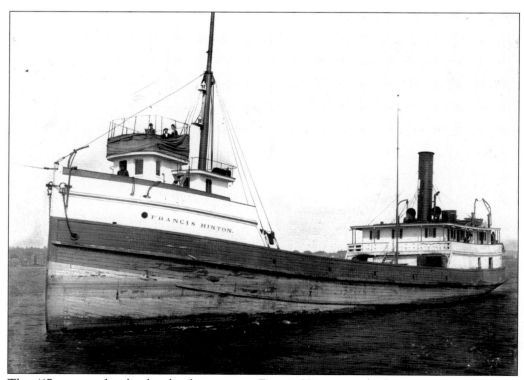

The 417-ton wooden lumber hooker steamer *Francis Hinton* was built at Hanson and Scove Shipyard at Manitowoc in 1889. (P82-37-7-100.)

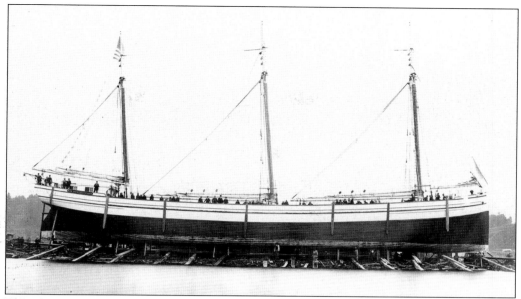

The schooner *S. M. Stephenson* is on keel blocks and ready for launching at the Rand and Burger Shipyard in 1880. Its owner was William Burns. (P82-37-7-108.)

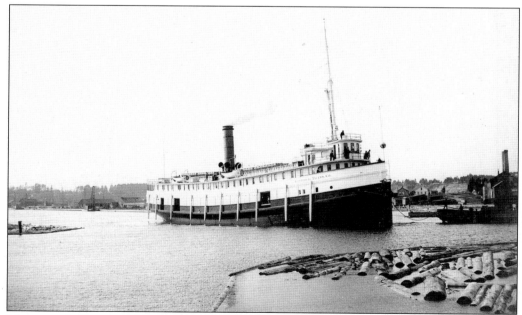

Manitowoc's Burger and Burger Shipyard built the steamer *City of Racine* in 1889. In 1909, it was rebuilt and re-boilered at the Manitowoc Shipbuilding Company. With a completely new profile, it was renamed the *Arizona*, and it operated as a passenger steamer for the Goodrich Line until 1926. (P82-37-9-13.)

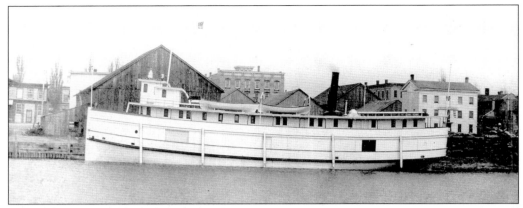

In 1890, Burger and Burger delivered the newly built *City of Marquette* to its owner, the Hill Steamship Line of Kenosha, Wisconsin. It is shown here tied up at the south end of North Ninth Street in Manitowoc. (P82-37-8-138.)

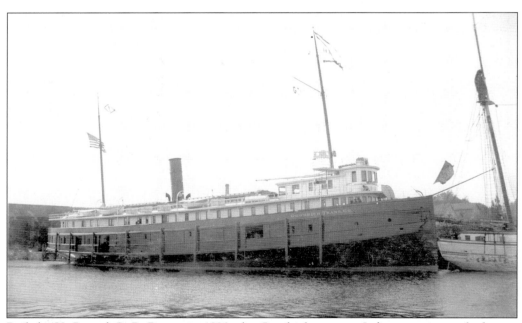

Built by H. B. and G. B. Burger in 1890, the Goodrich steamer *Indiana* receives a fresh coat of paint. In 1915, the *Indiana* was cut apart, re-boilered, and lengthened 22 feet. Manitowoc Shipbuilding Company performed this work in its graving dock in Manitowoc. The *Indiana* ceased operation as a passenger boat in 1928 and converted into a powerhouse and hotel for workers deepening the St. Mary's and Detroit Rivers. (P82-37-7-77.)

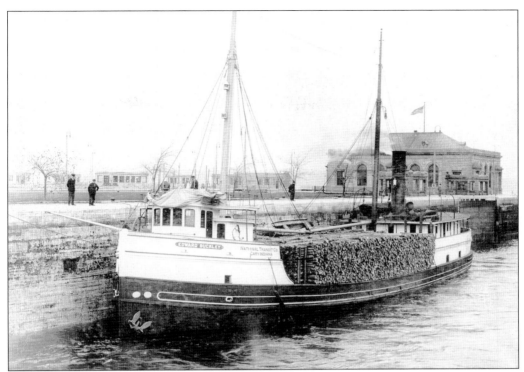

The lumber hooker *Edward Buckley* was built by Manitowoc's Burger and Burger Shipyard in 1891. It is shown in Sault Ste. Marie, Michigan, with a full load of pulpwood. (P82-37-8-39.)

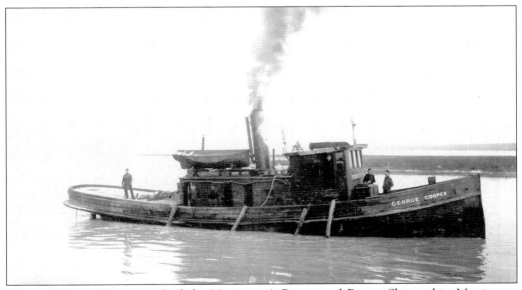

The tug *George Cooper* was built by Manitowoc's Burger and Burger Shipyard in Manitowoc in 1891. (P82-37-8-57.)

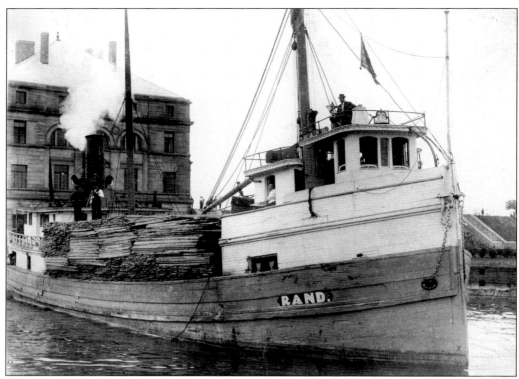

Manitowoc's Burger and Burger Shipyard built the lumber hooker *Rand* in 1887. Here it is shown at Sault Ste. Marie, Michigan, with a full deck load of lumber. (P82-37-8-37.)

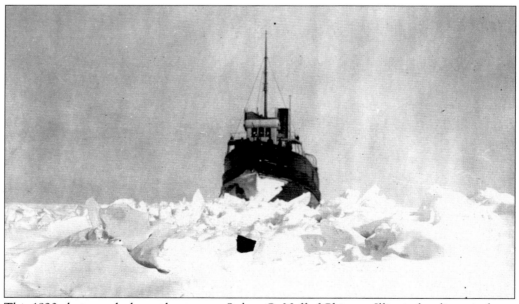

This 1920 photograph shows the steamer *Sydney O. Neff* of Chicago, Illinois, battling windrows of ice. It was built by Manitowoc's Burger and Burger Shipyard in 1894. (P82-37-8-149.)

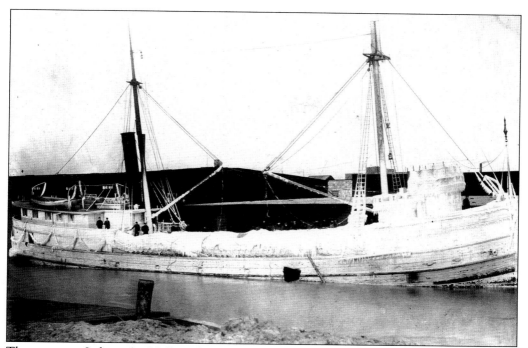

The steamer *Sydney O. Neff* is shown covered with ice after a fierce winter passage in 1899. (P82-37-8-157.)

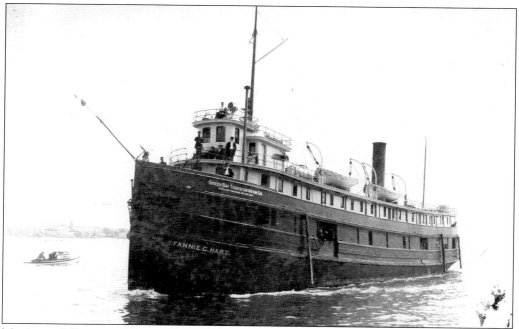

Manitowoc's Burger and Burger Shipyard built the steamer *Fannie C. Hart* in 1888. It was launched as a bulk freighter and later deepened to become a combination passenger and package freighter, as seen in this photograph. It operated primarily on Lake Michigan out of Green Bay, Wisconsin. The vessel left the Great Lakes in 1910 and finished its life in saltwater service. (P82-37-8-12.)

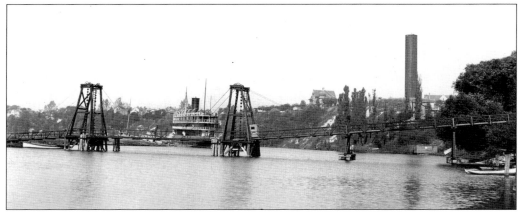

This 1899 photograph was taken looking upriver at the State Street Bridge in Manitowoc. The bridge was built in 1897 as a pedestrian crossing and provided Manitowoc's north-side workers easy access to the shipyards. The whaleback passenger steamer *Christopher Columbus* may be seen beyond the bridge. Sunk to the left of the *Columbus* is the steamer *D. F. Rosé*. On top of the hill sits the Schuette mansion, which serves as a funeral home as of 2005. The standpipe along the skyline to the right is the city water tower. (P82-37-7-147.)

The steamer *Iowa* is shown here leaving the Manitowoc Harbor. It was built by Manitowoc's H. B. and G. B. Burger in 1896. *Iowa* was caught by running block ice in the Chicago harbor and sank with a total loss of ship and cargo. The passengers and crew saved themselves by walking over the ice to shore. (P82-37-7-21.)

The 52-ton Goodrich Lines tug *Arctic* is shown entering the Manitowoc Harbor with a group of young ladies on the foredeck. Manitowoc's Rand and Burger Boatyard built it in 1881 for Goodrich at a cost of $16,015. The *Arctic* was designed for winter operations and icebreaking in the Milwaukee Harbor, but summer found it busy working in Manitowoc Harbor. In 1919, it underwent a complete rebuild at the Manitowoc shipyards. The vessel was abandoned in 1930 after serving 49 years, the longest continuous service record of any boat that sailed under the Goodrich flag. (P82-37-7-35.)

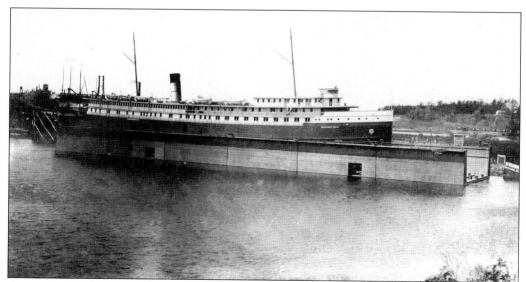

Owned by the Chicago and Duluth Transportation Company, the *Minnesota* sits in dry dock at the Manitowoc Shipbuilding Company's Berth B some time between 1910 and 1917. (P82-37-6-63.)

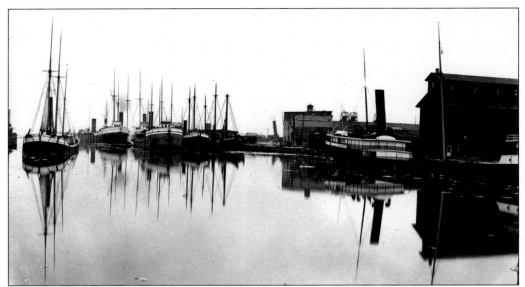

This 1900 winter scene of the lower Manitowoc River was taken from the Eighth Street Bridge looking toward Lake Michigan. (P82-37-7-145.)

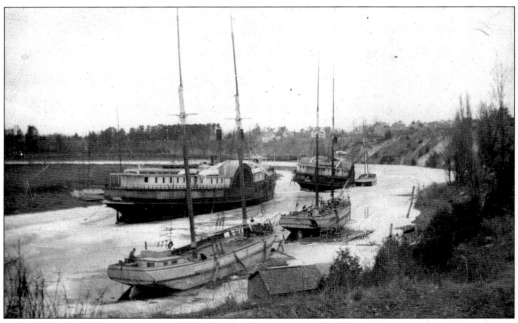

The Goodrich Lines side-wheel steamer *Chicago* and the remains of the side-wheeler *Muskegon* can be seen in this 1904 photograph of the upper Manitowoc River. Manitowoc's G. S. Rand Shipyard completed the *Chicago* in 1874. In 1916, Goodrich dismantled the steamer and sold the hull and upper works to the Manitowoc Shipbuilding Company, which used it as a dining hall and sleeping quarters for shipyard workers. In 1871, G. S. Rand also built the side-wheeler *Muskegon* in Manitowoc. It was wrecked in the Milwaukee Dry Dock Company's dock in 1896, when the blocking accidentally collapsed. The three schooners in the photograph are the *Isolda Bock*, the *Oscar Newhouse,* and the *Libbie Carter*. (P82-37-7-137.)

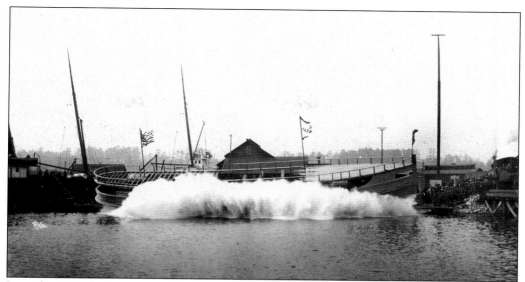

Launch of the passenger steamer *Chequamegon* took place in 1903. Burger and Burger began construction of the steamer, but the yard was sold to the Manitowoc Shipbuilding Company while construction was under way. As a result, the *Chequamegon* became Hull No. 1 for the Manitowoc Shipbuilding Company. (P82-37-8-120.)

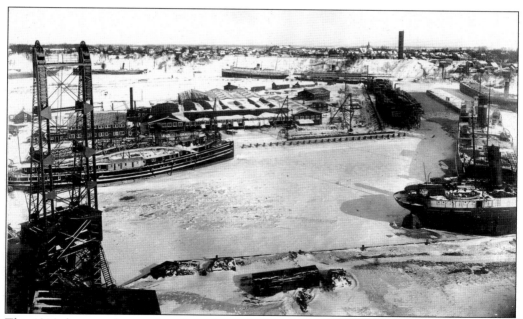

This 1916 photograph was taken from the roof of Northern Grain Elevator A. The picture shows the Manitowoc Shipbuilding Company, the lifting tower of the Soo Line Railroad lift bridge, and the Goodrich Transportation Company's side-wheeler *Chicago*, which the Manitowoc Shipbuilding Company purchased after its useful life had ended. The side-wheeler's paddle wheels have been removed so it can be used as a dining hall and sleeping quarters for shipyard workers. Four swivel cranes may be seen alongside Berth A and a traveling bridge crane at Berth B. (P82-37-8-143.)

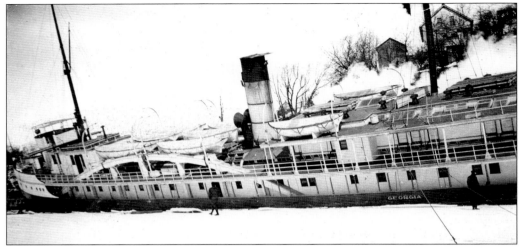

This 1920 photograph shows the Goodrich Lines steamer *Georgia* sitting on the bottom of the Manitowoc River after ice has pulled the caulking from its planking. Later that year, it was sold to Milwaukee's Crosby Transportation Company of Milwaukee, and it continued to operate as a steamer until 1924. The *Georgia* was finally condemned and sunk off Green Bay, Wisconsin's Summer Island, to serve as a breakwater. (P82-37-9-11.)

Former flagship of the Graham and Morton Line, the steamer *Grand Rapids* joined the Goodrich fleet in 1925. Here it is shown tied up at the Goodrich maintenance dock on the east bank of the Manitowoc River near Tenth Street. The American Shipbuilding Company built the vessel at their Cleveland yard in 1912. It had a gross tonnage of 3,061 and survived until 1952, when it was scrapped in Hamilton, Ontario. (P82-37-1-29.)

In 1893, the C. C. *Barnes* was dismasted in a squall on Lake Michigan and grounded on South Fox Island. The tug *Monarch* towed it to Manitowoc and is shown here assisting the schooner into the Lehigh coal dock to unload its cargo before being re-masted and sparred at Manitowoc's Rand and Burger Shipyard. (P82-37-7-22.)

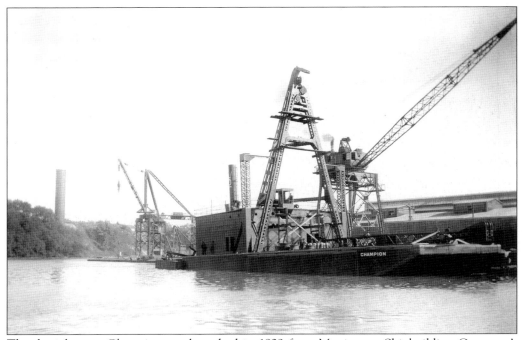

The derrick scow *Champion* was launched in 1929 from Manitowoc Shipbuilding Company's Berth D. Also shown in this photograph are the shipyard's stiff-leg crane and the water tower. (P82-37-1-30.)

The sand sucker *American* is shown tied up at Manitowoc Shipbuilding Company's Berth D. Directly behind in the photograph is an Ann Arbor carferry. The white stern of the boat entering the dry dock on the left is that of the U.S. Coast Guard cutter *Escanaba*. (P82-37-5-58.)

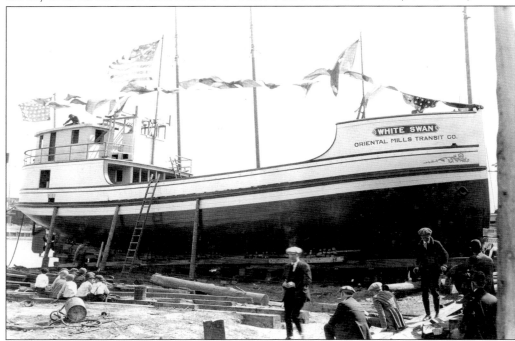

The *White Swan* readies for its 1922 launch at Manitowoc's Burger Boatyard. The fancy work and name existed only on the vessel's starboard side at the time this photograph was taken. (P82-37-9-79.)

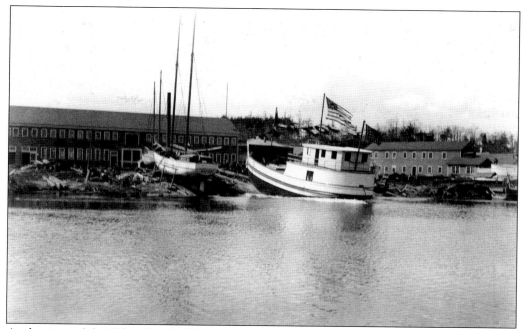

At the time of the *White Swan*'s 1922 launch, the Burger Boatyard was located on the opposite side of the Manitowoc River from the Manitowoc Shipbuilding Company. The vessel was built for John Schuette, who owned Manitowoc's Oriental Milling Company. This photograph also shows the schooner *Alice* nearly ready for launching as well. (P82-37-9-35.)

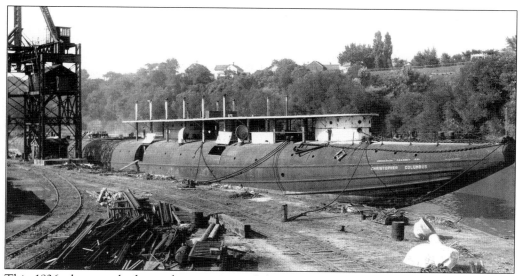

This 1936 photograph shows the scrapping of the famous Goodrich Line whaleback steamer *Christopher Columbus*. For many years, it made daily excursion runs between Milwaukee and Chicago. The vessel was also a familiar sight in the Manitowoc harbor because it wintered there between 1898 and its final lay-up between 1932 and 1936. The docking facilities for the Goodrich Line were in the same area where the Wisconsin Maritime Museum now is located. (P82-37-1-9.)

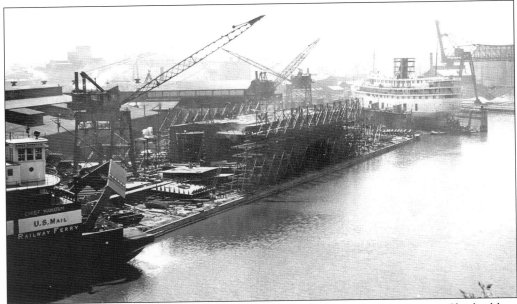

The tanker *Red Crown* is under construction in Berth D at the Manitowoc Shipbuilding Company. The famous carferry *Chief Wawatam* is shown on the left. The *Alabama* can be seen in dry dock being reconditioned for its new owner Earl G. Kirby. Kirby put the *Alabama* to work on the Cleveland to Isle Royale route. (P82-37-5-104.)

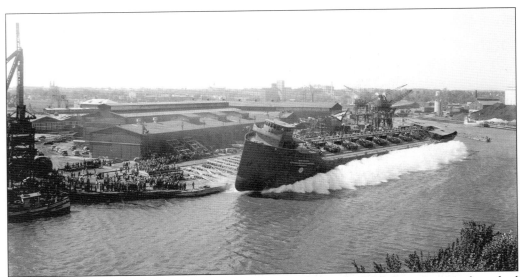

The *Red Crown* (Hull No. 292), an oil tanker built for the Standard Oil Company, was launched from Manitowoc Shipbuilding Company's Berth D in 1937 and was later renamed *Amoco Indiana*. In 2005, it still served the port of Manitowoc as a cement barge named *St. Mary's Conquest*. (P82-37-1-32.)

Two

THE AGE OF SAIL

The age of sail did not cover a specified time period. The change from sail to powered vessels was gradual. In more than a few cases, schooners were later fitted with auxiliary power plants to allow them to dock without the help of a tug or enabled them to continue on their way even though becalmed. In some cases, the use of the power plants was more or less constant and the sails were used mainly as steadying sails to cut down on rolling when traveling in a trough. By 1890, no more schooners or other sailing craft were being produced to be used as work boats. Those already in service continued to ply the lakes usually until they met with some sort of disaster that ended their career, and in many cases, the lives of those on board. By the end of the 1920s, they were all but a memory.

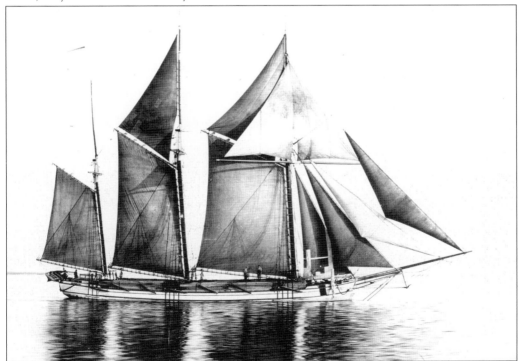

Built by Manitowoc's C. Henderson in 1870, the schooner *J. B. Newland* is shown in this photograph under full sail with a deck load of lumber. (P82-37-8-111.)

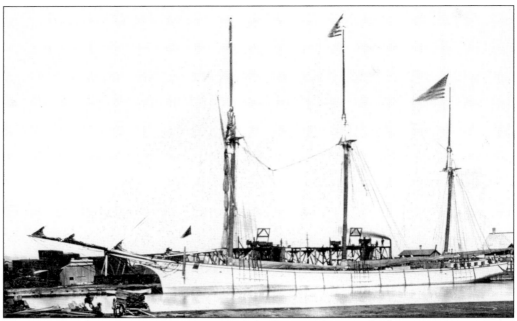

The 845-ton schooner *J. I. Case* was one of the largest schooners built in Manitowoc. Rand and Burger Shipyard built it in 1874, and its home port was Racine, Wisconsin. Due to the shallowness of the river at Racine, the *J. I. Case* may have never made its way upstream to the J. I. Case factory in Racine. (P82-37-2-37.)

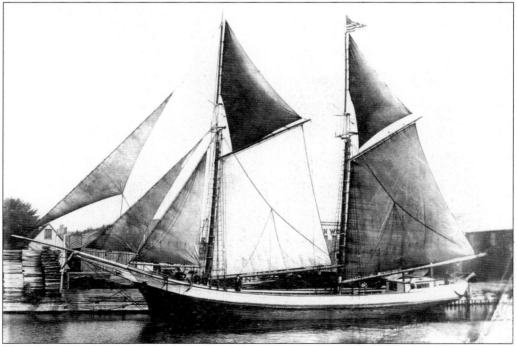

The schooner *Jessie Martin* dries its sails while tied up on the northern bank of the Manitowoc River between the Ninth Street and Tenth Street Bridges. (P82-37-7-40.)

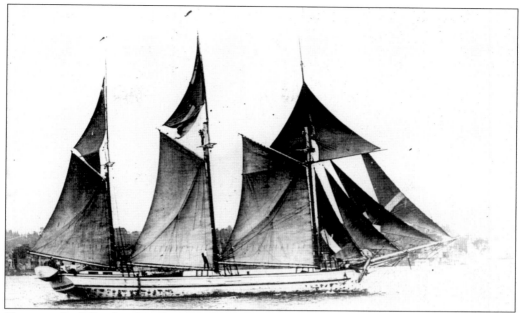

Shown under full sail in this photograph, the schooner *Emma L. Nielsen* was built by Manitowoc's Rand and Burger Shipyard in 1883. One of the *Emma L. Nielsen*'s deck hands appears to be encountering problems in the main crosstree trying to secure the foot of the topsail to the gaff. (P82-37-3-27.)

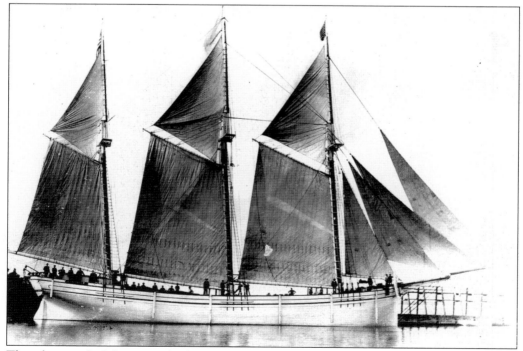

The schooner *G. J. Boyce* was built in 1884 by Manitowoc's Rand and Burger Shipyard, and it is shown entering the harbor at Ludington, Michigan. (P82-37-7-41.)

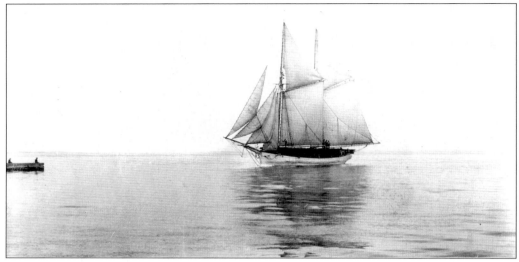

The *James H. Hall* was built by Manitowoc's Hanson and Scove Shipyard in 1885. The vessel is pictured under full sail with a large deck load. The *Hall*'s owners had a gasoline engine installed for auxiliary power to help extend its useful life. The *Hall* caught fire and was lost off of Lake Huron's Thunder Bay River in 1916. (P82-37-8-105.)

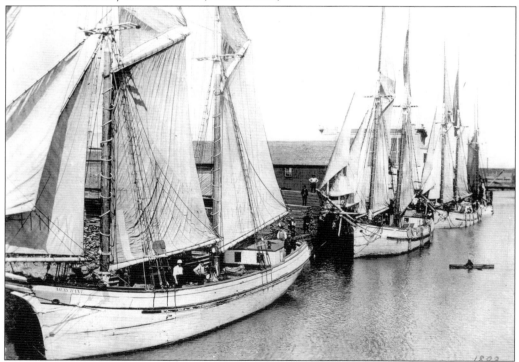

This 1893 photograph shows three schooners tied up on the north bank of the Manitowoc River at the foot of North Eighth Street. The schooner *Merchant* was built by P. Larson in 1874. Captain Jorgenson built the *Isolda Bock* in 1881, and the *John Hall* was built by the Hanson and Scove Shipyard in 1889. The photograph also shows the old Torrison Building and the steel swing bridge built in 1888. (P82-37-7-23.)

In this 1888 photograph, the schooner *Lizzie Metzner* is tied up on the south bank of the Manitowoc River above the Tenth Street Bridge. The vessel was built at the Rand and Burger Shipyard in Manitowoc. It worked the timber trade on Lake Michigan until 1904, when the *Metzner* was moved to Lake Ontario and driven ashore near Oswego, New York. The lumberyard and the Wisconsin Central Mill, in this photograph, survived until the 1960s. The house shown between the mainsail and the mizzen mast of the *Lizzie Metzner* survives at the time of this writing. (P82-37-7-116.)

The schooner *Grand Haven* is rigged with what was referred to as a "jackass rig." This type of rigging eliminated the main mast to ease loading and unloading. (P82-37-1-4.)

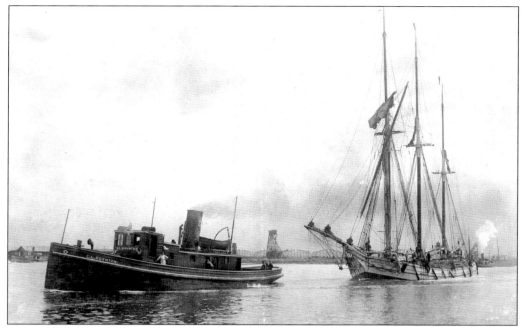

The schooner *Cora A.* was the last schooner built in Manitowoc. It was constructed by Manitowoc's Burger and Burger Shipyard in 1889. The vessel is shown being towed by the tug *C. L. Boynton.* (P82-8-108.)

The schooner *Burt Barnes* was built by Manitowoc's Rand and Burger Shipyard in 1882. It is shown here in 1893 on the north bank of the Manitowoc River just east of the Eighth Street Bridge. (P82-37-3-67.)

The schooner *Emma L. Nielsen* was built by Manitowoc's Rand and Burger Shipyard in 1883. This 1899 photograph shows the vessel tied up at the wood lot at the end of South Ninth Street in Manitowoc. Also seen in the photograph is Manitowoc's Oriental Mill and a fish market in the former Klingholz Brothers building. (P82-37-3-69.)

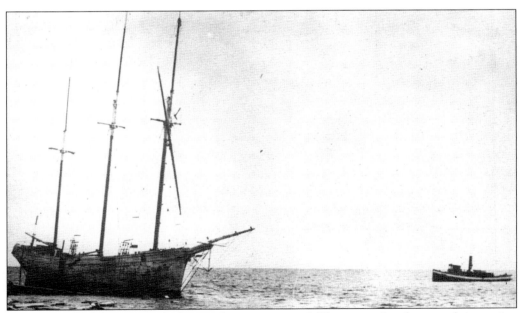

An unidentified three-masted schooner has run aground. The tug in the photograph is coming to its aid. (P82-37-5-83.)

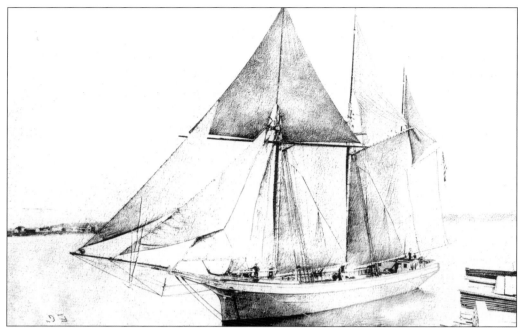

Captained by owner Herman Schuenemann, the *Rouse Simmons* foundered in 1912 off the coast of Two Rivers, Wisconsin, while it was sailing from Manistique, Michigan, to Chicago. All hands were lost along with the vessel. The *Simmons* is fondly remembered as the "Christmas tree ship" because it frequently delivered Christmas trees to the port cities along the western shore of Lake Michigan. The shipwreck of the *Rouse Simmons* was discovered in 1971. (P82-37-8-110.)

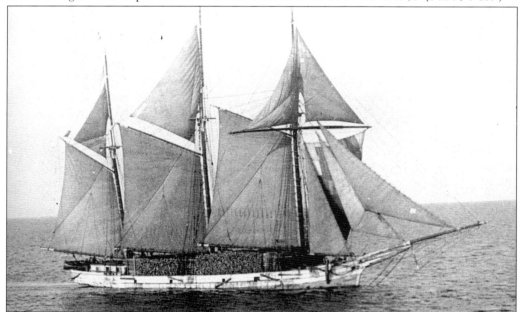

The schooner *Lucia A. Simpson* was the last of Lake Michigan's "Great White Fleet." Manitowoc's Rand and Burger Shipyard built the *Simpson* in 1875. It is shown under sail with a full deck of pulpwood in this 1926 photograph. (P82-37-2-55.)

Three

THE SHIPPING SCENE AT MANITOWOC

During the late 1880s and early 1890s, a paradigm shift took place in the marine industry. The speed and predictability of steam-powered vessels aided in the demise of sailing vessels. Over a short period of time, steamships replaced the "Great White Fleet" of schooners. In 1902, the Burger and Burger Shipyard, owned by Henry and George Burger, was sold to the founders of the Manitowoc Dry Dock Company. This sale poised Manitowoc to take advantage of the paradigm shift. The principle owners of Manitowoc Dry Dock Company were Charles West, Elias Gunnell, and Lynford Geer. Their strong interest in constructing steam-powered steel vessels provided a catalyst that would make Manitowoc a hub for shipping, shipbuilding, and ship repair well into the 20th century.

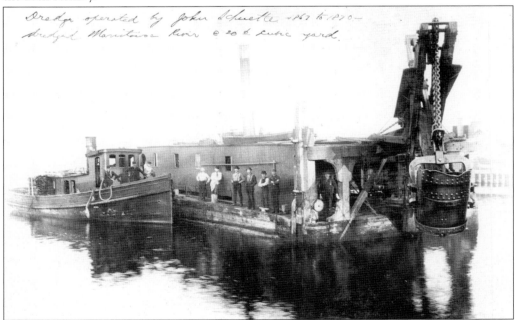

Manitowoc Harbor is being dredged in this late 1860s photograph. The dredge operator was John Schuette, who spent his lunch hour clearing the harbor for 20¢ per cubic yard of dredge material. Schuette also served as president of the Manitowoc Savings Bank, which later became known as Associated Bank. As bank president he knew the importance of a good harbor to a port city's commerce. (P82-37-9-64.)

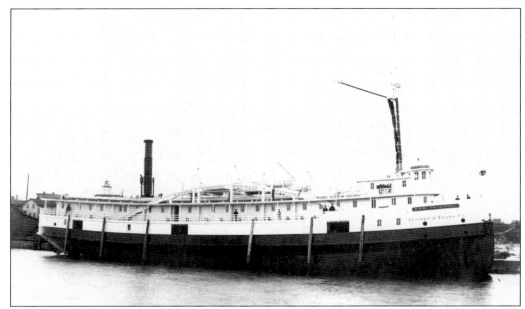

The Goodrich steamer *Ludington* was built by the G. S. Rand Shipyard of Manitowoc in 1880. In 1898, it was rebuilt, lengthened, and renamed *Georgia*. Manitowoc's original land-based lighthouse can be seen behind the smokestack of the vessel. (P82-37-7-130.)

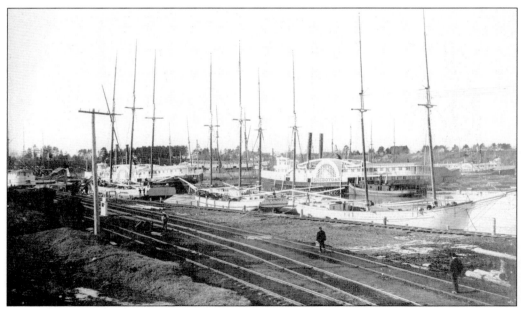

The 1887–1888 winter fleet in Manitowoc is comprised of the Goodrich Line side-wheeler steamers *Sheboygan* and *Chicago* and the Goodrich tug *Arctic*. The schooners seen in the foreground are the *Linerla*, the *James H. Hall*, and the *Success*. The dredge is the same one shown previously that was operated by John Schuette. The *Petosky* is seen on the stocks and is nearly ready for launching. Around the bend of the Manitowoc River can be seen the side-wheeler steamer *Corona*. (P82-37-9-45.)

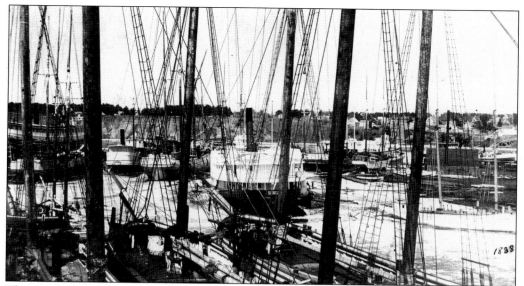

The 1887–1888 winter fleet in Manitowoc is a forest of masts. The Goodrich side-wheeler *Muskegon* shows its stern in the center of the photograph. Located to its right is the *Corona*, with the *Petosky* sitting on the stocks to its left. A stern view of the lumber hooker *A. D. Hayward* is shown along with the schooner *Henry C. Richards*. The wintering of these vessels and others provided Manitowoc with a regular seasonal source of revenue. Winter maintenance and repair were commonplace in Great Lakes port cities. Fitting out as the new shipping season approached also provided an important market for Manitowoc's merchants. This photograph was taken the same day as the previous photograph. (P82-37-7-43.)

This 1887 Manitowoc River photograph shows the first wooden swing bridge on Eighth Street. A year later, this wooden swing bridge was replaced by a steel girder swing bridge, and in 1924, a steel lift bridge was erected. The present lift bridge was installed in the late 1990s. The schooner *Mediterranean* is shown sitting crosswise in the river. This schooner delivered Manitowoc's first steam locomotive, which was named Benjamin Jones and was owned by the Milwaukee, Lake Shore and Western Railroad. (P82-37-7-20.)

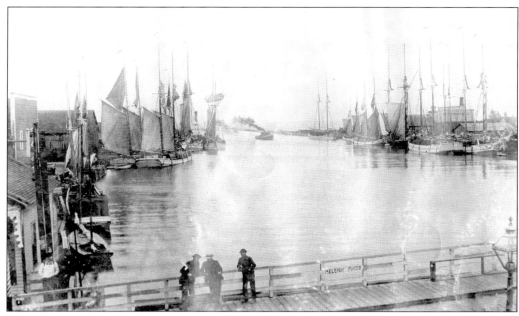

The Torrison General Store was located at the corner of Eighth Street and the street now named Maritime Drive. The store location offered photographers a good view from the roof for taking harbor shots. This 1887 photograph shows the wooden Eighth Street Bridge in Manitowoc. (P82-37-7-2.)

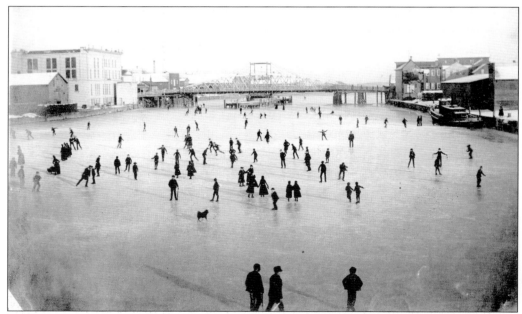

Ice-skating was a popular pastime in 1888, as is seen in this winter harbor scene in Manitowoc. This photograph was taken between the Eighth Street and Tenth Street Bridges. The Goodrich Line tug *Arctic* is shown on the far right. Most of the winter fleet was moored further up the Manitowoc River, out of view in this photograph. (P82-7-44.)

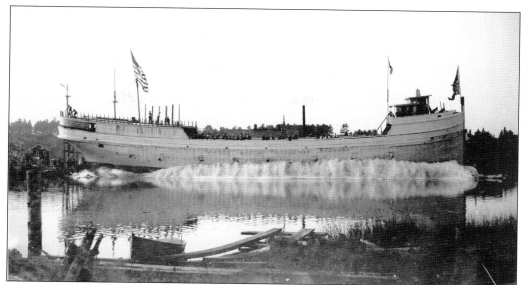

The freighter *Isabella J. Boyce* was launched from Manitowoc's Burger and Burger Shipyard in 1889. (P82-7-121.)

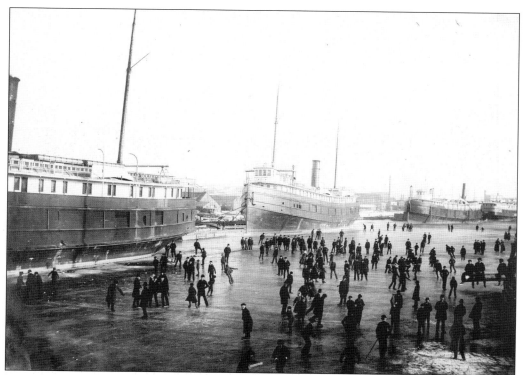

Young and old alike enjoyed ice-skating on the Manitowoc River, as is seen in this 1890 photograph. The vessels alongside the north bank of the river are the *Racine*, the *De Pere*, and the *Menominee*. The Goodrich Lines owned all of these steamers. (P82-37-7-46.)

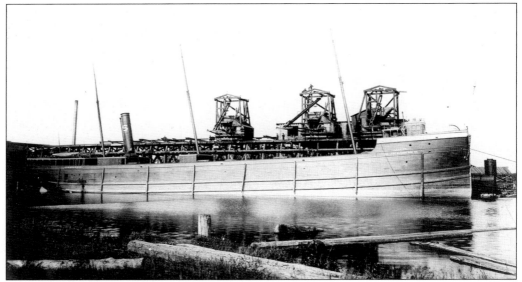

This 1890 image shows the steamer *La Salle* tied up alongside the coal docks along the Manitowoc River near South Sixteenth Street. In 1898, the coal docks were torn down, taking the life of Simon Schinoha, who fell and broke his back while working on the project. The firebox type of boiler, shown just forward of the bow of the *La Salle*, remained a fixture in that location for many years. (P82-7-139.)

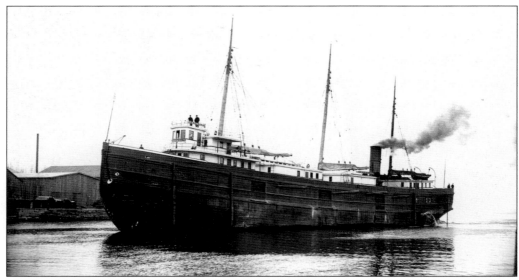

The break-bulk freighter *Flint and Pere Marquette No. 5* is shown entering the Manitowoc River in 1890. It was built in Bay City, Michigan, just a few years earlier. (P82-37-7-7.)

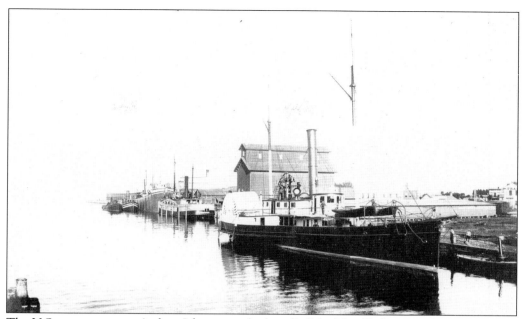

The U.S. revenue cutter *Andrew Johnson* was built at Buffalo, New York, in 1865. In 1881, it was rebuilt at Manitowoc (see also P82-37-7-54 on pg. 15). The wrecking tug *Favorite No. 2* and the *Nevada* and the tugs *Monarch* and *Arctic* may also be seen in this 1890 photograph. (P82-37-7-74.)

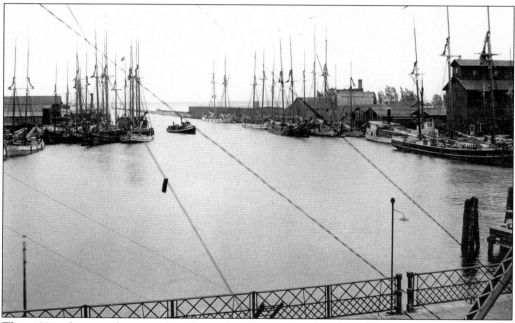

This 1891 photograph was taken from the G. Torrison General Merchandise Store roof at Manitowoc. G. Torrison owned several vessels, which he used to ship merchandise to his store. The new swing bridge on Eighth Street was built in 1888. The heavily loaded schooner is the *Rosabelle*, and at the far right is the schooner *Monguagon*. The tug is unidentifiable. (P82-37-7-15.)

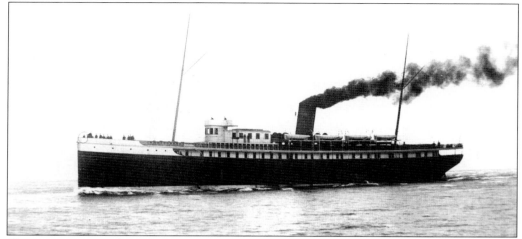

Shown in its original configuration, the steamer *Virginia* was built at the Globe Iron Works in Cleveland, Ohio, in 1890. Over a period of many years, it was rebuilt twice at the Manitowoc Shipbuilding Company. In 1918, its name was changed to the USS *Blue Ridge* and it saw service in salt water. At the end of World War I, its name was changed to *Avalon* and it began serving the route between southern California and Catalina Island. The vessel was scrapped in 1960. (P82-37-7-128.)

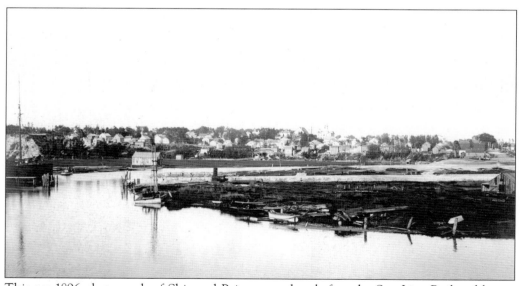

This pre-1896 photograph of Shipyard Point was taken before the Soo Line Railroad began providing service to Manitowoc. While the railroad bed has been built for the tracks, the rails need to be laid, a lift bridge needs to be erected, and the carferry docks need to be built. Shipyard Point was the site of several different shipyards in the early years of Manitowoc shipbuilding. (P82-37-7-30.)

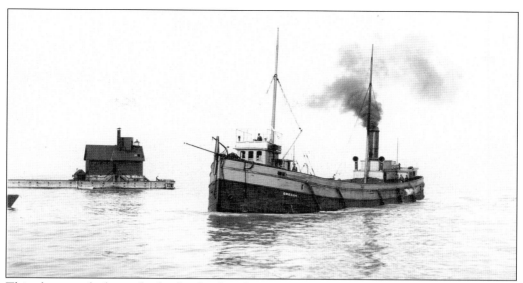

This photograph shows the lumber hooker *Oregon* entering the Manitowoc Harbor in the late 1890s or early 1900s. The vessel was built at Bay City, Michigan, in 1882. In 1908, it ran aground and burned in Georgian Bay and was a total loss. (P82-37-9-28.)

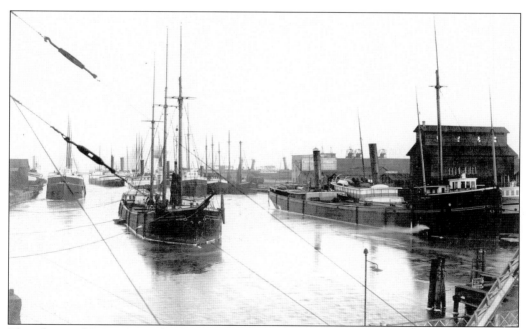

The schooner *H. A. Hawgood* is shown with a full load and tied up in the middle of the Manitowoc River in this 1897 photograph. Across the river, the steamer *George T. Williams* can be seen, and the *Mary McLauglin* is on the left along with other vessels of the winter fleet. (P82-37-7-28.)

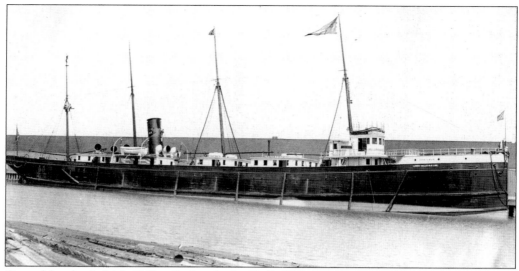

Owned by the Lehigh Valley Railroad, the *E. P. Wilbur* is shown tied up at the Wisconsin Central Warehouse at Manitowoc in 1898. The *Wilbur* was one of four identical vessels built for the railroad. At that time, they were considered the finest-looking vessels on the Great Lakes. In 1917, the federal government's United States Shipping Board requisitioned all four vessels for the World War I war effort. The vessels were cut in two, and the sections were towed through the Welland Canal to salt water. Once they passed through the canal, the bisected vessels were put back together, but none of them ever returned to the Great Lakes. (P82-37-7-120.)

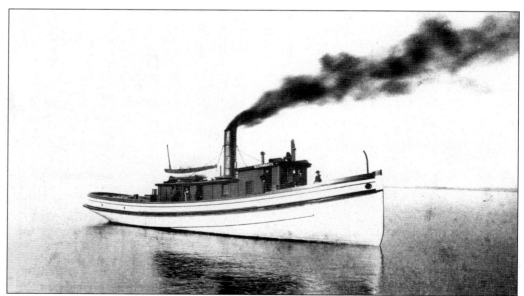

In this 1892 photograph, the tug *Geo. Pankratz* is shown waiting for a tow. This vessel was built by Manitowoc's Rand and Burger Shipyard in 1882. (P82-37-9-22.)

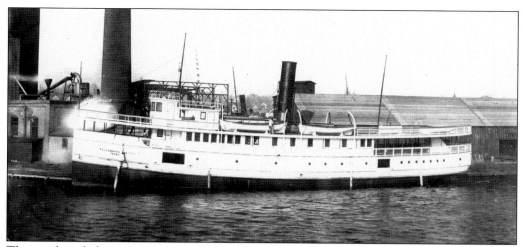

This unidentified steamer was owned by the Escanaba and Gladstone Transportation Company of Michigan. It is shown in 1897 tied up near the powerhouse of Manitowoc's Northern Grain Elevator A. The framework shown behind the pilothouse in the background is most likely a new coal dock on Shipyard Point. (P82-37-7-34.)

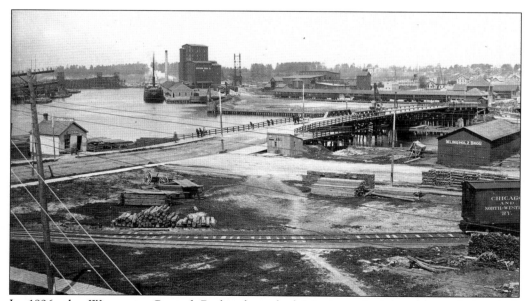

In 1896, the Wisconsin Central Railroad reached Manitowoc's downtown and the city's downtown area took on a new look. Nearly all the buildings across the Manitowoc River were less than two years old when this photograph was taken in 1898. The lumber hooker *Mark B. Covell* is tied up alongside the Wisconsin Central Warehouse, which is just upriver from the newly built carferry dock. (P82-37-7-106.)

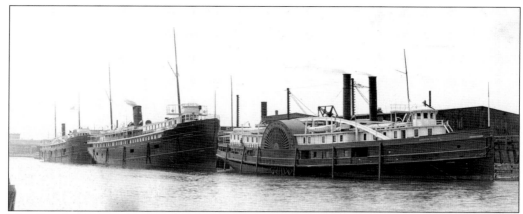

The Goodrich Line steamers *Chicago*, *Virginia*, and *Georgia* are lined up along the Goodrich docks at Manitowoc. The *Chicago* was built by Manitowoc's G. S. Rand Shipyard in 1884. The *Virginia* was built by the Cleveland Iron Works Company in Cleveland, Ohio, in 1891. The *Georgia* was constructed as the *City of Ludington* by G. S. Rand in 1881. Its name was changed to *Georgia* after an 1888 rebuild. (P82-37-7-131.)

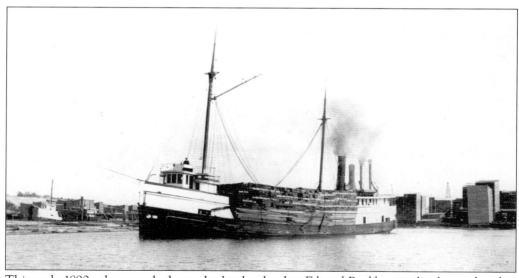

This early 1890s photograph shows the lumber hooker *Edward Buckley* at a lumberyard with a massive deck load of wood shingles. The *Buckley* was built by Manitowoc's Burger and Burger Shipyard in 1881. Also in the photograph, the *Mark Covill*, which was also built by Burger and Burger, can be seen on the far left. (P82-37-7-140.)

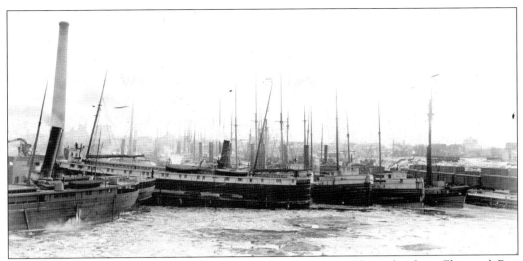

In 1898, part of Manitowoc's winter fleet consisted of the package freighter *Flint and Pere Marquette No. 2*. It is docked near the powerhouse for Northern Grain Elevator A. The lumber hooker *Cumberland* is also visible among other vessels. (P82-37-9-85.)

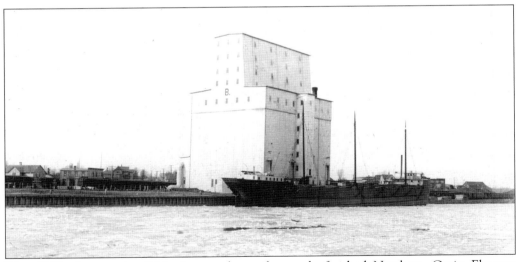

This 1898 photograph of Manitowoc shows the newly finished Northern Grain Elevator B, two years prior to a 1900 annex addition. In 1962, a spectacular fire destroyed the entire structure. (P82-37-9-85-2.)

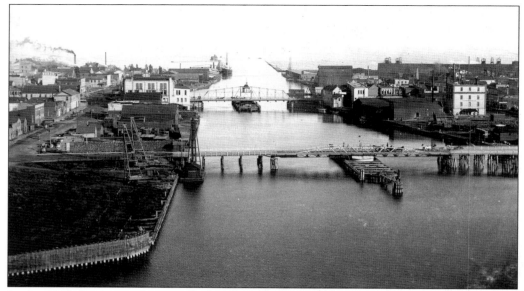

In this 1898 downriver photograph, shot from the newly built Northern Grain Elevator B, the Eighth Street Bridge, which was built in 1888, can be seen in the background. The Tenth Street Bridge had been recently reconditioned by turning it over and running the bridge deck between the curved trusses (see photograph P82-37-7-106 on page 53 for comparison) at the time the photograph was taken. A boat near the mouth of the Manitowoc River can be seen at the Goodrich Transportation Line docks. (P82-37-7-14.)

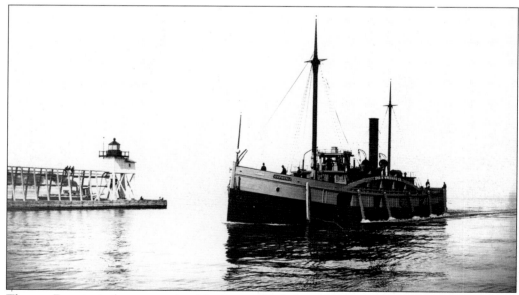

The tug *Favorite* is shown entering Manitowoc Harbor in 1902. It was built in 1864, sold to the Great Lakes Towing Company in 1902, and burned in 1907. Another tug can be seen behind the Manitowoc Breakwater. (P82-37-7-24.)

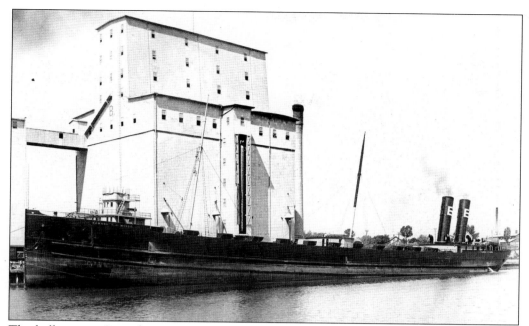

The bulk carrier *Samuel F. B. Morse* was built by the United States Steel Company in 1898. The vessel is shown tied up at Manitowoc's Northern Grain Elevator B. This photograph can be dated from 1900 or later as the annex has been added to the elevator. (P82-37-7-119.)

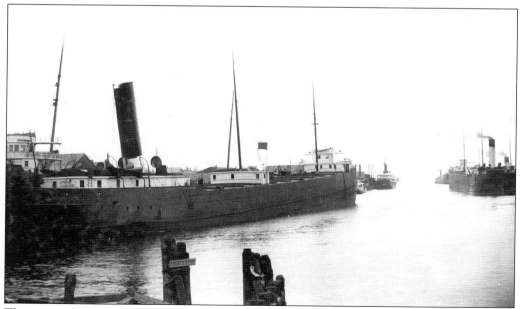

The stern of the *George Stephenson* and the bow of the *James Watt* can be seen in this 1907 photograph. This shot was taken from the Eighth Street Bridge looking downriver at Manitowoc. As the sign on the swing bridge guard shows, a cigar still cost 5¢ in 1907. (P82-37-7-13.)

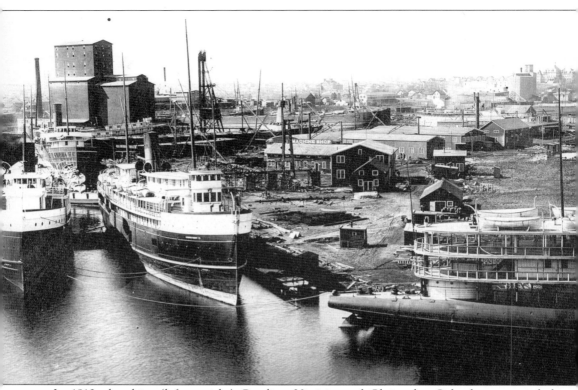

In 1910, the ships (left to right) *Carolina*, *Virginia*, and *Christopher Columbus* occupied the Manitowoc Shipbuilding Company docks. The recently built *Alabama* is still being fitted out and can be seen behind the *Virginia*. The *Virginia* had recently undergone its second rebuilding. Its silhouette was completely altered with the addition of a top pilothouse and Texas deck. (P92-13-1-1.)

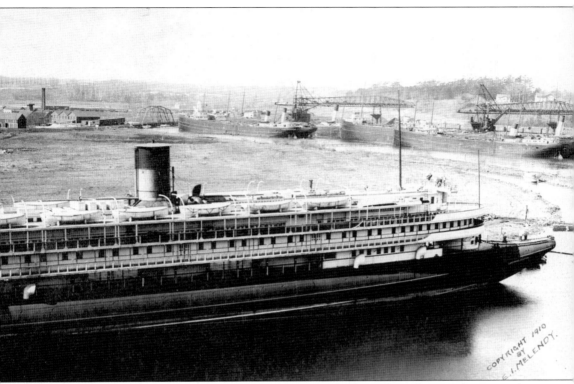

This 1910 scene of the Peninsula at Manitowoc shows six bulk carriers along with two coal unloading docks for the Reiss Coal Company. The Reiss Coal Company was based in Sheboygan, but it had docking facilities at many of the port cities along the west coast of Lake Michigan. The coal dock later became the location of the Portland Cement Company. (P92-13-1-2.)

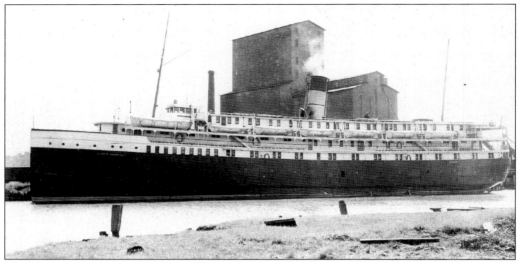

The newly built passenger steamer *Alabama* is shown tied up in this 1910 photograph. It is tied up just north of the Soo Line Railroad lift bridge in Manitowoc. (P82-37-3-55.)

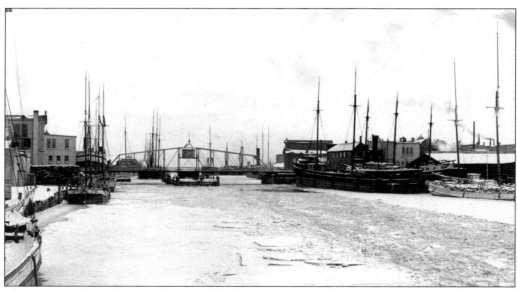

This picture shows that the Manitowoc River channel was kept open in the winter of 1899 so that carferries could reach the Wisconsin Central Railroad slip upriver. The steamer *Queen of the West* is docked on the south side of the river. It was built in 1881 by William Crosthwaite Shipyard in Bay City, Michigan. (P82-37-7-145.)

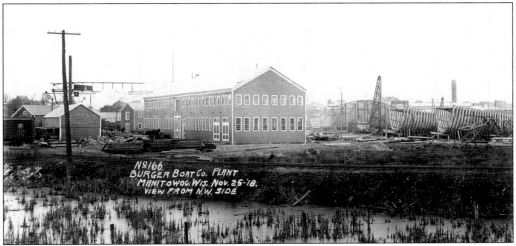

The newly constructed Burger Boatyard facility, erected across the river from the Manitowoc Shipbuilding Company, can be seen in this 1918 photograph. The Burger building was later enlarged, nearly doubling its size, and was used until August 2005 when it was demolished. To the right of the building can be seen the ribs of two 100-foot tugs that Burger built during World War I. The names of the tugs were the *Retriever* and *Terrier*. Burger built a total of six tugs for the United States World War I war effort. Across the river from the Burger Boatyard, alongside Manitowoc Shipbuilding Company's Berth 4, can be seen a "Laker," a small sea-going cargo vessel that is equipped with a wide pilothouse. To arrive at the carferry docks, the Soo Line train must first cross the swing bridge then cross a lift bridge at the other side of the Peninsula. Also seen in this photograph is Manitowoc's municipal water tower. (P95-2-122.)

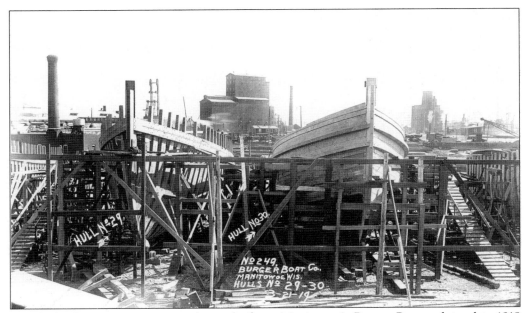

Two U.S. Government tugs are being built at Manitowoc's Burger Boatyard in this 1918 photograph. (P95-2-175.)

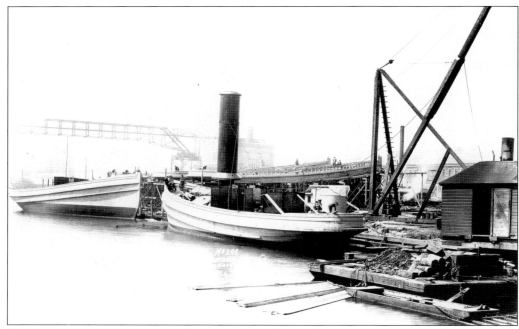

The tug *Terrier* has been launched at Manitowoc's Burger Boatyard in 1919. Its boiler can be seen in the hull, and other hulls can also be seen. (P95-2-206.)

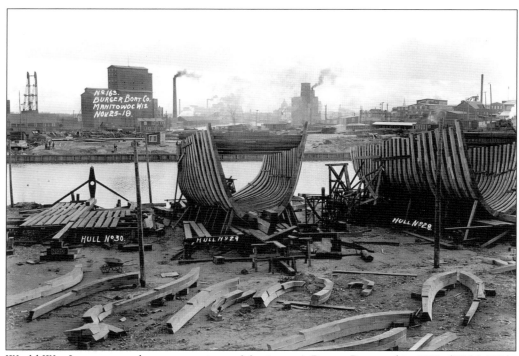

World War I tugs are under construction at Manitowoc's Burger Boatyard in 1918. (P95-2-119.)

Three of the six U.S. Government tugs being built by Manitowoc's Burger Boatyard can be seen in this 1920 photograph. All of the tugs were built of wood and measured 100 feet in length. They were all named after dog breeds, with *Spaniel* on the left, *Pointer* in the middle, and *Beagle* on the right. Each tug carried a crew of eight. (P95-2-236.)

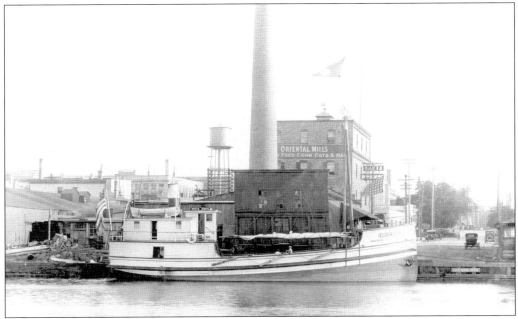

This mid-1920s Manitowoc photograph shows the *White Swan* tied up at its docking facility near the Oriental Milling Company on Ninth Street. (P82-37-8-114.)

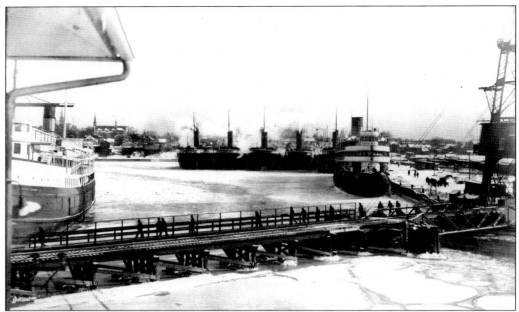

This 1920 Manitowoc winter scene shows (left to right) the *Arizona* and the bulk freighters *Calumet, Corvus, Pegasus, Lagonda,* and *Mars*. All of the vessels were built between 1896 and 1910. The *Christopher Columbus* is also visible in this photograph. (P82-37-8-83.)

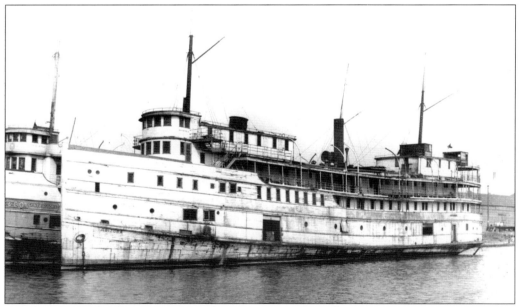

Two former Goodrich Line steamers, the *Arizona* and the *Indiana*, are awaiting their fate. The *Arizona* was originally built in 1889 as the *City of Racine* by Manitowoc's H. B. and G. B. Burger Shipyard. It was rebuilt in 1909 and renamed the *Arizona*, and it served as a passenger steamer until 1926. The *Indiana* was built at the same yard as the *Arizona*, and it served as a passenger steamer until 1928. Both vessels were later employed as powerhouse and housing facilities for workers deepening the St. Mary's River. (P82-37-9-23.)

Four

LAKE MICHIGAN'S CARFERRIES

Manitowoc has had a long association with the Lake Michigan carferries. These specialized ships first appeared on the lake in 1892, when the *Ann Arbor No. 1* entered service between Frankfort, Michigan, and Kewaunee. Loaded railcars were transported across the lake rather than being routed by train around it. Significant cost savings and up to three days of delay in the Chicago railroad yards were realized by the railroads operating the ferries. By 1896, service was extended between Frankfort and Manitowoc. When the ferries first entered service, the cars that they carried were strictly railroad freight cars and the carferries provided this service faithfully for nine decades. During the late 1980s, most of these rugged ships were retired as obsolete by advances in railroad technology. Today only automobiles are carried on the last surviving carferry, SS *Badger*, on its route between Manitowoc and Ludington.

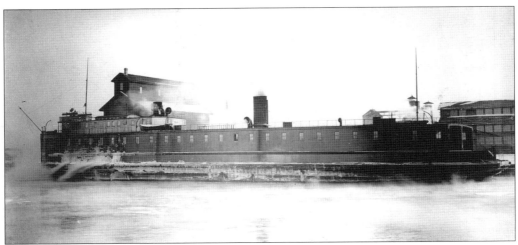

The *Ann Arbor No. 1* is pictured in Manitowoc after seeking shelter from a storm in January 1893. This photograph predated construction of Manitowoc's ferry slips by a few years. (P82-37-11-132.)

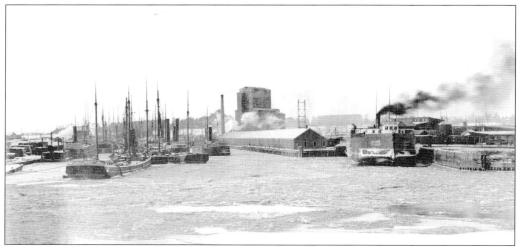

The early carferries serving Manitowoc coexisted with the last of the great schooner and lumber hooker fleets. *Ann Arbor No. 2*, right, is shown loading at the Wisconsin Central Railroad slip. At left, in the winter lay-up fleet, are a number of sailing vessels and a few lake steamers. (P82-37-7-57.)

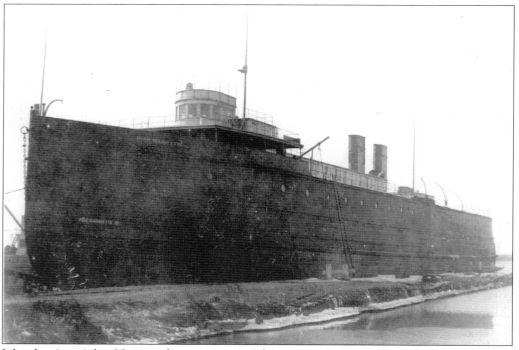

Like the *Ann Arbor No. 1* and its twin *Ann Arbor No. 2*, the *Pere Marquette 16*, shown here, was one of the first-generation wooden-hulled railroad carferries. Grossly underpowered for its size, the *Pere Marquette 16* suffered numerous mishaps throughout its career. The *Pere Marquette 16* ran between Ludington, Michigan, and the Wisconsin ports of Manitowoc, Kewaunee, and Milwaukee. (P82-37-3-84.)

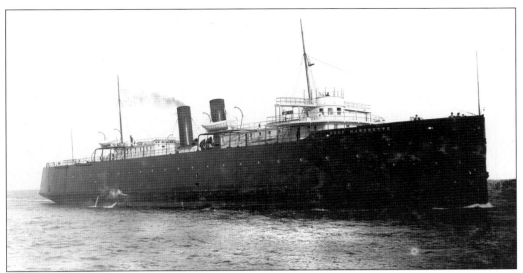

In February 1897, the Flint and Pere Marquette Railroad began service of the first steel-hulled open-water carferry in the world. The steamer *Pere Marquette* shown here during its first few months in service was placed on the 60-mile run between Manitowoc and Ludington. Later renamed *Pere Marquette 15*, it was maintained and rebuilt over the span of its 37-year career at the Manitowoc Shipbuilding Company's yard. The *15* was scrapped at Manitowoc during the winter of 1935–1936. (P82-37-7-61.)

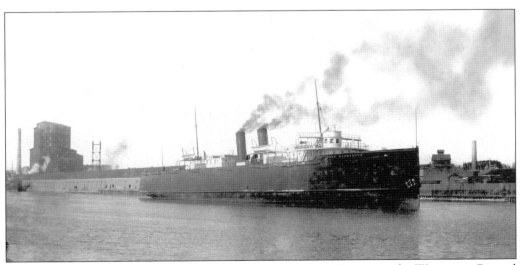

The *Pere Marquette* is shown maneuvering in the Manitowoc River near the Wisconsin Central Railroad slip shortly after entering service in the spring of 1897. This 350-foot carferry was designed by naval architect Robert Logan, and it set the standard for all later Great Lakes carferries. (P82-37-7-37.)

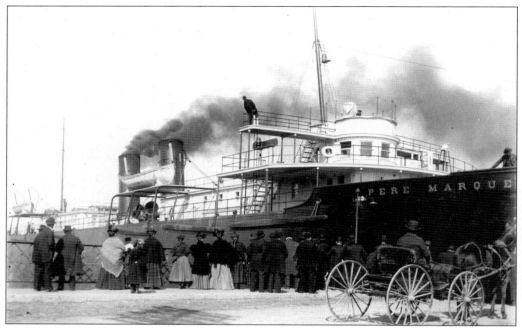

The carferry *Pere Marquette* passes through the swing-span of the Eighth Street Bridge on the Manitowoc River. This magnificent view was taken in the spring of 1897 and shows a crowd of onlookers watching the ferry's passage with great interest. Capt. Joseph Russell was the vessel's first regular master. (P82-37-9-86.)

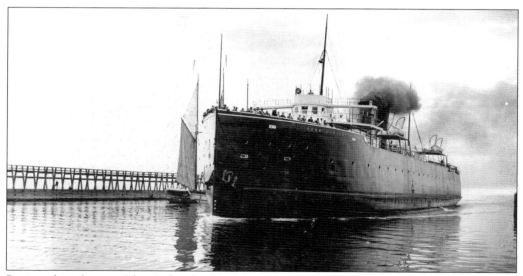

Passing the schooner *Silver Lake*, the *Pere Marquette* enters the channel at Manitowoc Harbor. Powered by a pair of fore and aft compound engines and four coal-fired Scotch boilers, the ferry's twin screws churned out 2,500 horsepower, capable of pushing the ship at a speed of 12 miles per hour. All Lake Michigan carferries were designed for year-round service. (P82-37-8-117.)

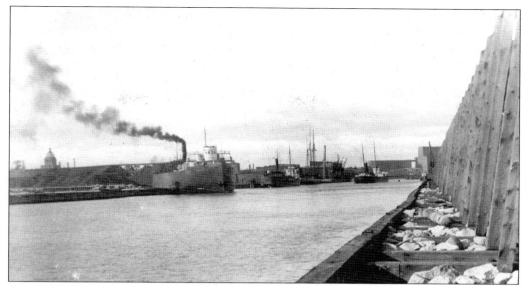

Ann Arbor No. 3 is shown at left departing from its lakefront slip at Manitowoc. Like many other vessel fleets, the Ann Arbor ferries were serviced and refurbished at the Manitowoc Shipbuilding's yard throughout their history. The yard also built the Ann Arbor Railroad's flagship *Ann Arbor No. 7* in 1925. (P82-37-436.)

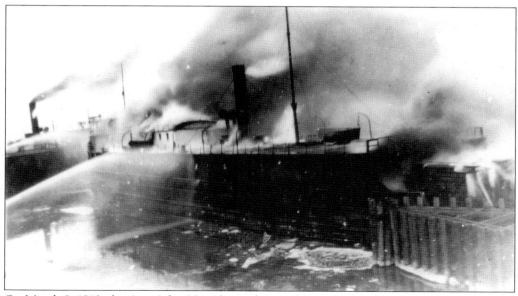

On March 8, 1910, the *Ann Arbor No. 1* burned in its slip on the lakefront at Manitowoc. There were no injuries, but the ship was a total loss. It was towed to Frankfort, Michigan, and sunk near the south breakwater. The vessel was later raised after being deemed a menace to navigation, and it was rebuilt as a sand scow for the Love Construction Company. The ship's final fate is unknown. (P82-37-3-33.)

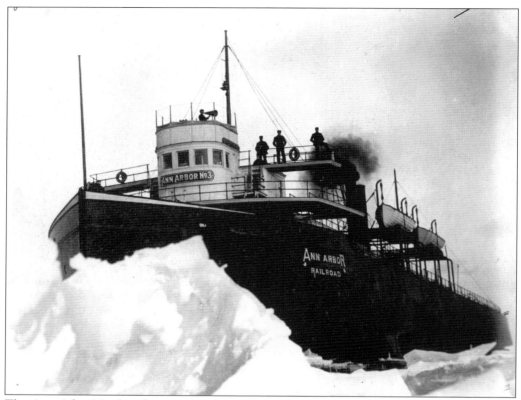

The *Ann Arbor No. 3* is shown trapped in a heavy field of windrow ice in February 1905. The ferries were heavily constructed to withstand the pressure ridges formed by sustained winds that piled up the ice along the east coast of Lake Michigan. (P82-37-5-71.)

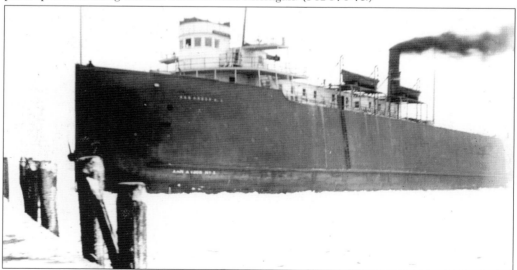

Stuck in a field of slush ice, *Ann Arbor No. 3* works its twin screws to free itself. The *No. 3* was put under the command of one of the lake's most famous carferry skippers, Capt. Charles E. Robertson. (P82-37-8-64.)

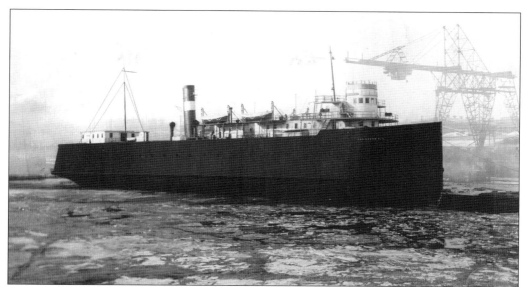

Lying at the yard of the Manitowoc Shipbuilding Company, *Ann Arbor No. 3* shows off its newly refurbished cabins and a coat of fresh paint. This photograph, retouched by an artist, was likely used in advertising for the shipyard or the Ann Arbor Railroad Company. (P81-78-4.)

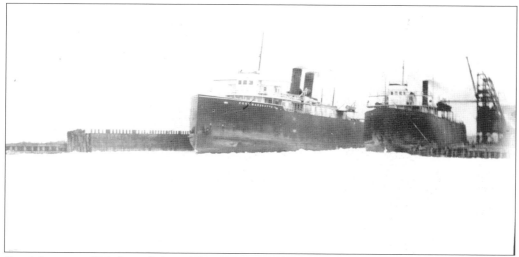

Pere Marquette 17, left, and *Ann Arbor No. 4* are shown "holding for weather" in ice-clogged Manitowoc Harbor while conditions subside in the open lake. Although the carferries operated in most any lake conditions, the decision not to sail rather than taking a beating outside was left to the discretion of the ships' captains. (P82-37-4-39.)

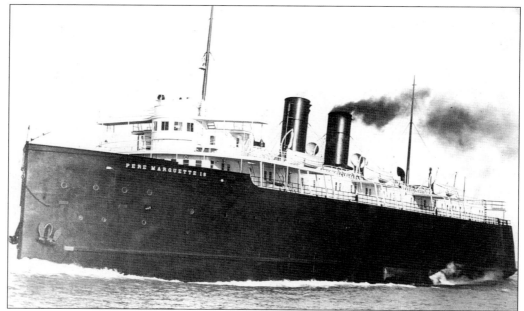

Naval architect Robert Logan's most elaborately designed carferries were the 1902-built *Pere Marquette 18*, shown here, and its sister ship *Manistique Marquette and Northern 1*, built in 1903. Unfortunately, the twins both sank on Lake Michigan with great loss of life. The *18* sank in 1910, and the *Manistique*, which was renamed *Milwaukee*, was lost in 1929. (P82-37-8-113.)

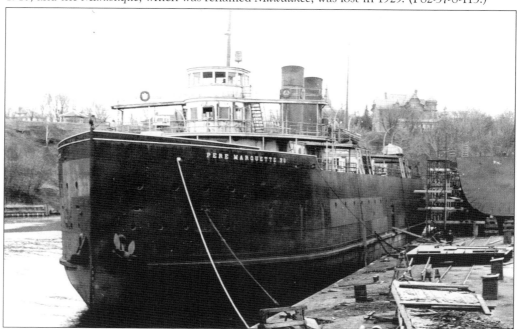

During the years of the Great Depression, the first generation of the Lake Michigan carferries became obsolete as newer ships arrived in the 1920s and 1930s. The *Pere Marquette 20* was retired in the late 1930s and is shown here at Manitowoc for conversion to an automobile ferry for service at the Straits of Mackinac. The *20* was renamed the *City of Munising*. (P82-37-2-58.)

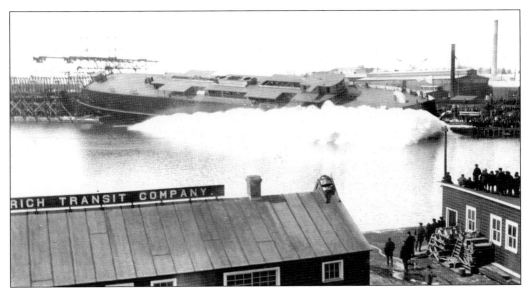

Pere Marquette 21 is shown being launched at Manitowoc Shipbuilding on March 18, 1924. The launch was nearly disastrous when one of the yard workers wielding a broad axe missed the after hawser, allowing the bow to enter the water first. Had the worker not recovered as fast as he did, the stern could have hung up with the bow swinging sideways and breaking its keel. Pneumatic guillotines were later used to prevent such mishaps. In spite of its inauspicious beginning, the *21* went on to have a successful career. (P82-37-3-50.)

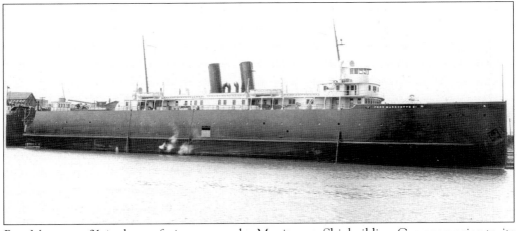

Pere Marquette 21 is shown fitting out at the Manitowoc Shipbuilding Company prior to its sea trials in 1924. It was the lead ship in a class of six nearly identical and highly successful ferries known informally as "the Standard Manitowocs" or "the Manitowoc Six." These vessels included the *Pere Marquette 21* and *22*, built in 1924 for the Pere Marquette Railway, and the *Ann Arbor No. 7*, which was built in 1925 for the Ann Arbor Railroad. In addition, the Grand Trunk Railway built the *Grand Rapids*, *Madison*, and *City of Milwaukee* in 1926, 1927, and 1931 respectively. (2001-1-520.)

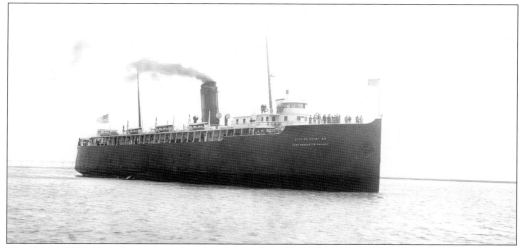

The *City of Flint 32*, shown here, and its sister ship *City of Saginaw 31* were built at Manitowoc Shipbuilding between 1929 and 1930. The 380-foot vessels were among the fastest carferries on Lake Michigan, with a top speed of 20 miles per hour. The reason for their speed was a pair of steam turbo-generators, which furnished the vessels' two direct drive propulsion motors a total of 7,200 shaft horsepower. (P82-37-11-120.)

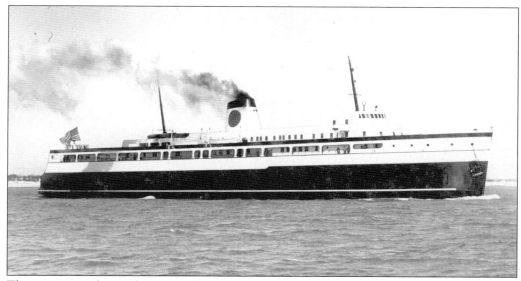

The most popular and successfully designed single carferry produced by the Manitowoc Shipbuilding Company was the 406-foot streamlined *City of Midland 41*. The ship served the Pere Marquette Railway, Chesapeake and Ohio Railway, and the Michigan-Wisconsin Transportation Company for a total of 47 years. In 1997, after languishing at its lay-up berth in Ludington, Michigan, the *41* was converted to a deck barge, renamed *Pere Marquette 41*, and remains in service as of autumn 2005. (P82-37-11-129.)

Five

LAKERS OF THE GREAT WAR

World War I began in Europe in 1914. The event that began United States engagement in the war was the loss of the British passenger liner *Lusitania*, which was sunk by a German submarine with the loss of 128 American lives. The following year, the Manitowoc Shipbuilding Company began building small seagoing cargo vessels, referred to as "Lakers," for the Norwegian and British Governments. The Lakers were built to carry materials that were needed to continue the war effort. With the United States entering the war, the U.S. Shipping Board Emergency Fleet Corporation requisitioned all the Lakers that the Manitowoc Shipbuilding Company had under construction or on order. Over the course of the war, the company built 33 Lakers. The names of the early Lakers built for the British government carried British names that all started with the word "war." When the U.S. Government took over these vessels, their names were changed so that the ship's name started with the word "lake," thus *War Cloud* became *Lake Linden*.

The Burger Boat Company was also very active constructing naval vessels for the U.S. Navy and U.S. Emergency Fleet Corporation. Burger built a total of nine vessels, including wooden subchasers and tugs.

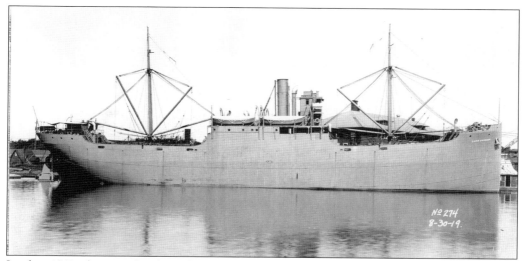

In this 1919 photograph, the Laker *Lake Gadsden* is seen sitting alongside the Manitowoc Shipbuilding Company administration building in Manitowoc. The Plimsoll marks that indicate the loading line of the vessel are high out of the water. This is a late version of a Laker. Kingposts are located between the cargo holds rather than having Sampson posts ahead of and behind the holds. As with the final design of Lakers built at Manitowoc, it also had a much wider pilothouse than the earlier Lakers. (2001-1-113.)

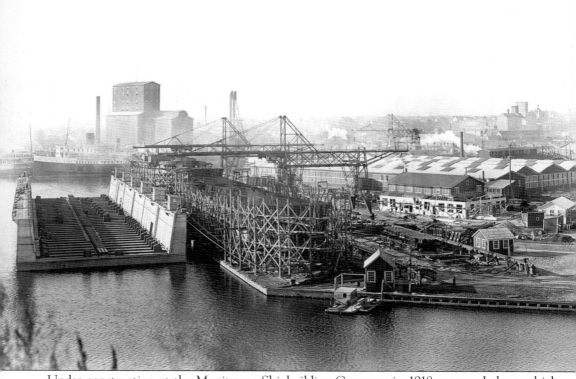

Under construction at the Manitowoc Shipbuilding Company in 1918 are two Lakers, which were being built for the American war effort in World War I. Also shown on the left is the empty floating dry dock. The two bridge cranes that were recently added are still traveling on rails mounted on temporary wooden posts. To the right of the photograph, the chain-drive ferry is transporting workers from one side of the Manitowoc River to the other. The Goodrich Lines steamers *Arizona* and *Christopher Columbus* are seen behind the dry dock. Also, a rivet shop is being added to the original Gunnel machine shop. (P95-2-125L.)

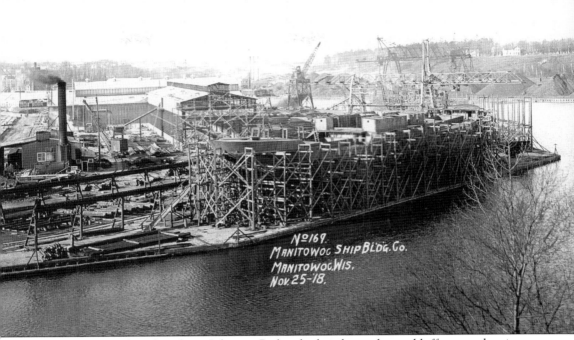

This 1918 photograph, taken from Schuette Park, which is located on a bluff across the river from the Manitowoc Shipbuilding Company, shows two Lakers on the building ways at Berths C and D. Also under construction are two machine shop buildings, and the upper floor of the nearest building will soon become the mold loft. The bridge crane on Berth C has recently been moved from Berth B and is running on rails mounted on steel posts much higher than the rails on Berth B. Hull plates for the Lakers can be seen laying on the ground on the far left side of the photograph. (P95-2-125R.)

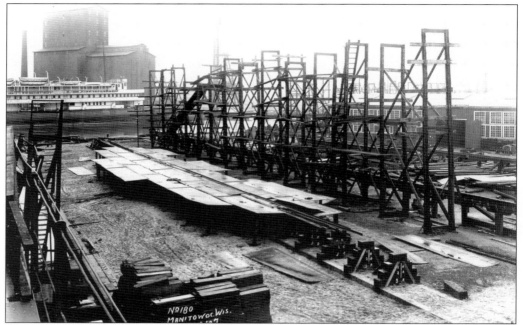

Shown in this 1918 photograph are the keel plates for the *Lake Savus* on Berth B-1 at the Manitowoc Shipbuilding Company. This vessel had several name changes, including *Ozark*, *Hai Kan*, and *Ping*, before it was scrapped in 1959. The Goodrich whaleback steamer *Christopher Columbus* can also be seen in the background. (P95-2-126.)

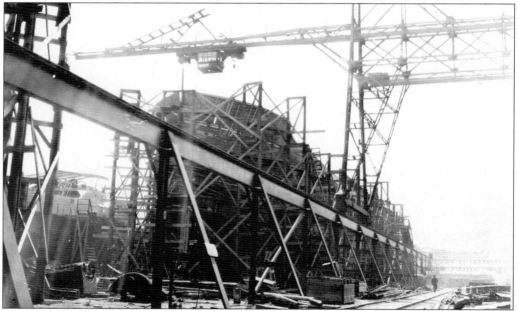

Seen here is a 1919 bow view of the *Lake Savus* under construction on Berth B-1 at the Manitowoc Shipbuilding Company. All the engines installed on the Lakers built at Manitowoc could develop 1,250 horsepower, and all Lakers displaced 3,400 deadweight tons. Note the new higher steel mountings for the crane rails that gave the cranes greater clearance. (2001-1-112A.)

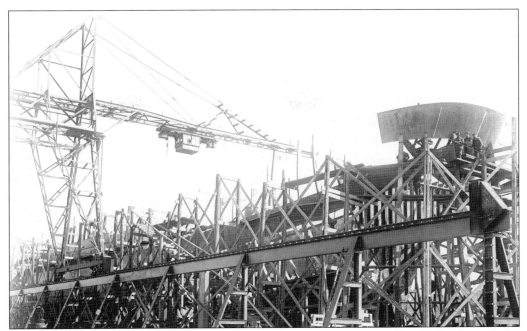

This is a view of the stern of the *Lake Savus* while under construction. Hundreds of rivet holes had to be drilled and filled with rivets to hold the ship's plates and frames together. (2001-2-174.)

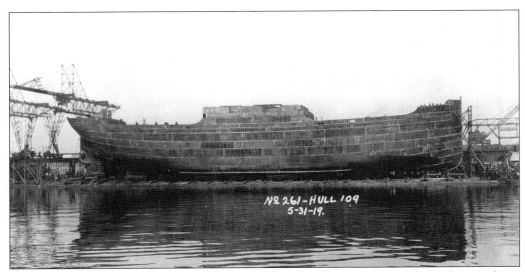

Nº 261 - HULL 109
5-31-19.

This 1919 photograph shows the *Lake Galata* ready for launching from Berth B. The vessel was one of the 33 Lakers built at the Manitowoc Shipbuilding Company in World War I. Note its bilge keel on the lower hull. (2001-1-116.)

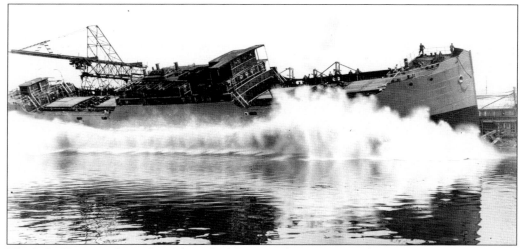

The *Lake Haresti* is shown being launched from Berth A in 1919 at the Manitowoc Shipbuilding Company. After its World War I service, the ship had its name changed to *Osseola* and later to *Commercial Floridian* before 1938, when it was sold to Russia and its name changed to *Shchors*. (2001-1-120.)

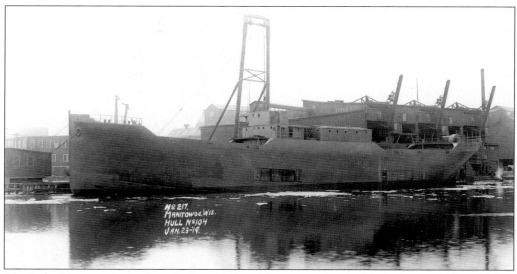

The *Lake Cornucopia* was launched in 1919 at Manitowoc Shipbuilding Company. It was then moved downriver to the Manitowoc Boiler Works where its Scotch boilers were installed. The vessel was later sold to the Bethlehem Steel Company and renamed *Cornore*. With the sale of *Cornore* to Norway, its name was changed to *Belize*. It was reported missing in 1941. (P95-2-144.)

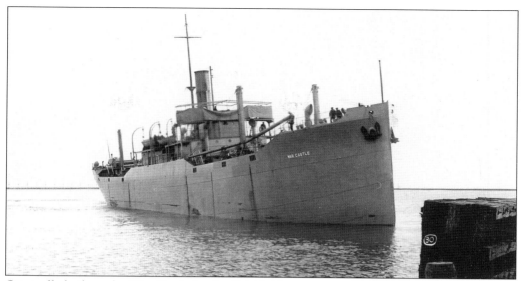

Originally built as the *War Castle* for the British Government, this Laker's name was changed to *Lake Ontario* when the federal government took ownership. As this 1917 photograph shows, the vessel is on a slight starboard list because it is only half coaled up. It is turning around and backing into the Reiss Coal Docks to have its bunkers filled on the port side. The pilothouse did not offer much protection for the helmsman because he stood watch under canvas. This vessel ended its productive life as scrap metal at the Ford Motor Company in Dearborn, Michigan. (2001-1-784.)

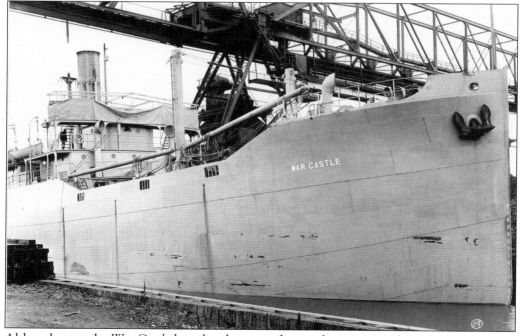

Although new, the *War Castle* has already received some damage as evidenced by the scraped paint on its hull. This 1917 photograph shows the *War Castle* backed into the Reiss Coal Dock at Manitowoc. (2001-1-786.)

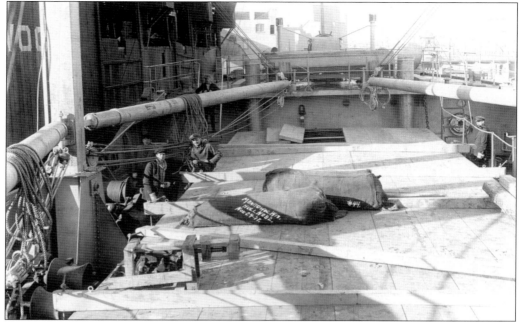

The *War Castle* is shown nearing completion in this 1917 photograph. Looking astern from the vessel's center, the steering station can be seen. Five shipyard workers can also be seen along the deck of the *War Castle*. In the background is the downriver side of Manitowoc's Eighth Street Bridge. (2001-1-788.)

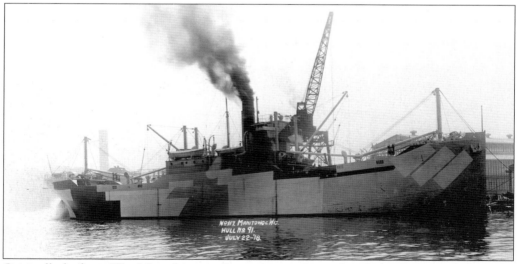

Originally built as *War Mist*, this vessel's name was changed to *Lake Greenwood* when the U.S. Government took ownership. The vessel already has a special dazzle camouflage paint scheme and is undergoing dock trials. This photograph shows it in 1917, moored at Manitowoc Shipbuilding Company's Berth D with water being whipped up by its propeller. The vessel was later sold to A. H. Bull and Company and renamed *Catherine*. The vessel had several other names during its working years, including *Stratford*, *Granton Glen*, and *Ann de Bretagne*. It was scrapped in Europe in 1955. (2001-1-184.)

The *Lake Greenwood* design was altered somewhat from earlier Lakers built at Manitowoc. It had a small pilothouse to offer more protection for the helmsman and its dazzle camouflage was extended up to the deckhouse. (2001-2-183.)

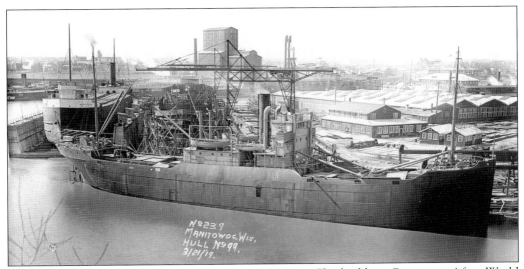

The *Lake Copera* was built in 1919 at the Manitowoc Shipbuilding Company. After World War I, it served on the Great Lakes, and it was renamed *Aetna I* and *Saginaw*. The vessel was reactivated for World War II service, and its name was changed to USS *Matinicus*. At the end of World War II, it went back into private service and its name changed to *Gemini*. In 1967, it ended its career in Finland having served as the *Ramsdal* and *Transdal*. The other vessel in the dry dock is the bulk carrier *Francis L. Robbins*, which was built in 1905. (P95-2-165.)

A third design alteration of the Lakers built at Manitowoc is seen in this 1918 photograph of the *Lake Corapeak*. It has a much wider wheelhouse that contains the chart room. The Sampson posts and king posts are still located ahead and behind the cargo holds rather than between them as in later designs. After World War I, *Lake Corapeak* was sold to an American firm and renamed *Chipana*. It was last owned by a Chilean company and named *Castilla*. The vessel foundered in the south Atlantic in 1954. (P95-2-143.)

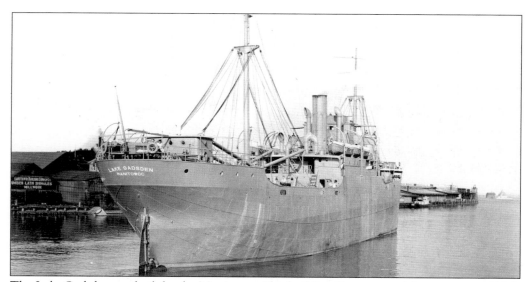

The *Lake Gadsden* was built by the Manitowoc Shipbuilding Company at Manitowoc in 1919. It is seen passing the Goodrich Line docks at Manitowoc as it leaves the port of Manitowoc. The vessel was later sold to the Lykes Company, and its name was changed to *American Genevive*. This Laker was then sold to the Panamanian government in 1947 and underwent name changes to *Lake Gaes*, *Kamran*, *Constancia*, *Sondervig*, *Olga*, and *San Nicola*. In 1954, it became stranded off of the Spanish Coast and slid off into deeper water. (P95-2-272.)

Six

THE YACHTING SCENE

Although the Burger Boat Company is known today for its sumptuous yachts, the business built far more working vessels during the early part of the 20th century. Burger Boat produced yachts as well, but these pleasure boats were made of wood and were small in comparison to today's mega-yachts. On the other hand, Manitowoc Shipbuilding Company did produce some larger yachts, a few of which were sumptuous even by today's standards.

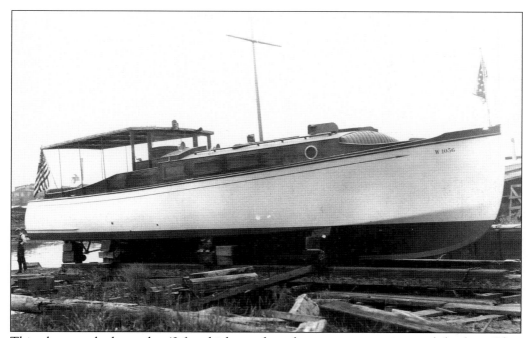

This photograph shows the 42-foot high-speed vee-bottom motor cruiser and day boat *Silver Heels* built in 1924 for Herbert Wuesthoff of Milwaukee. The pleasure craft was designed and built by Burger Boat Company. Note that the boat is set up for end launching rather than the more common side launching used locally for launching larger vessels. (P86-7-16.)

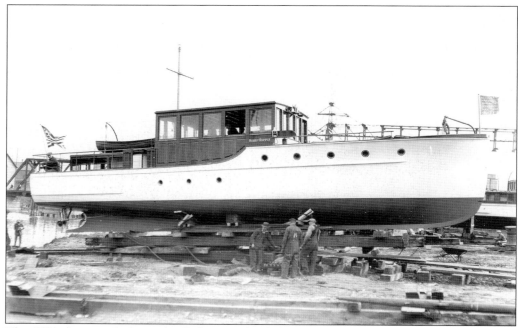

This 1924 photograph shows the 52-foot wooden-hulled yacht *Merry Ripple* (Job 120A in Burger's record books) shown on the blocks at the Burger Boat Yard ready for end launching. This boat was built for R. S. Ripple, while the 39-foot motor cruiser to the right was built for C. J. Peterson. Fine wood paneling and varnished deckhouses were the norm for the time. (P86-7-12.)

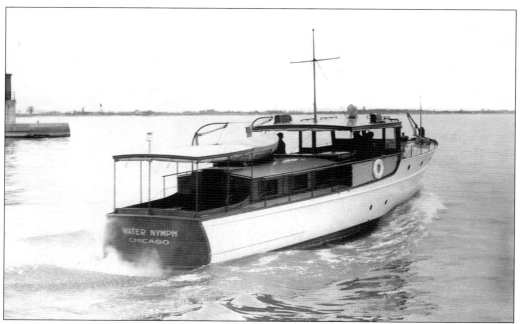

This raised-deck cruiser, the *Water Nymph* is shown leaving Manitowoc Harbor on sea trials. It was built by Burger Boat Company in 1931 (Job 356A) for Ralph Soquet and J. M. Conway. It measured 45 feet and 10 inches in length. (P86-7-15.)

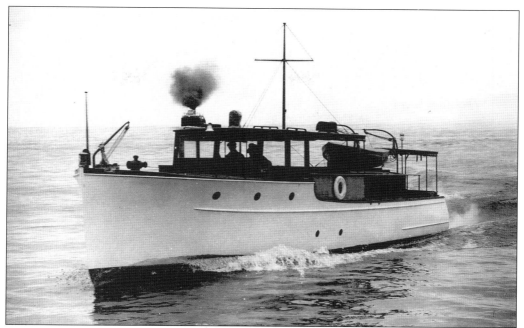

The 1931 46-foot raised-deck cruiser *Water Nymph* returns to Manitowoc from sea trials. The carferry *Pere Marquette 22* may be seen coming up behind it. (P86-7-14.)

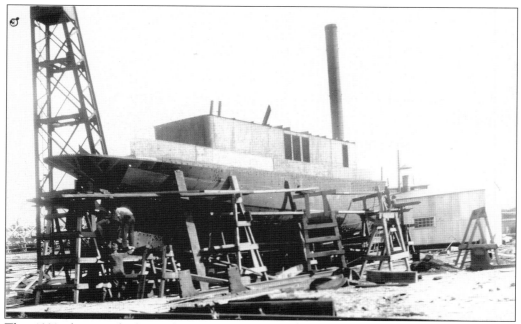

This 1929 photograph shows the 71-foot yacht *Reality* (Hull 248) on the ways at Manitowoc Shipbuilding Company. (2001-1-749.)

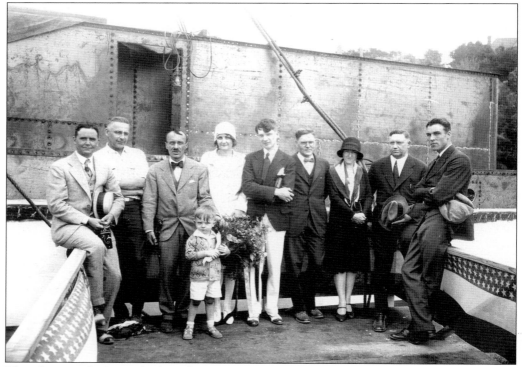

This photograph shows the launching party for the yacht *Reality* with its hull showing in the background. (2001-1-753A.)

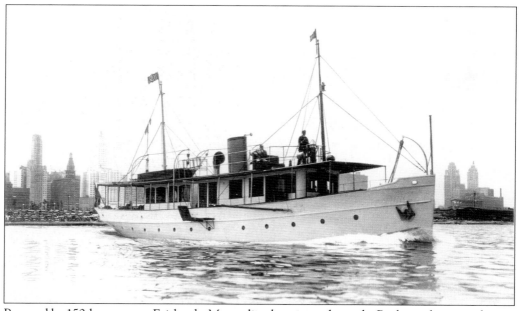

Powered by 150-horsepower Fairbanks Morse diesel engines, the yacht *Reality* is shown underway with the Chicago skyline in the background. Basic dimensions for *Reality* were: 71 feet in length, 15-foot beam, 7-foot draft, 62 gross tons, and 42 net tons. (2001-1-748.)

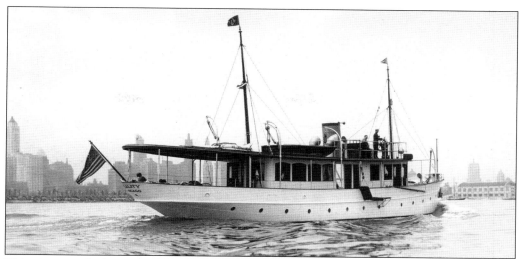

This photograph shows another view of the yacht *Reality*, which was owned by Karl Nibecker of Cicero, Illinois, who moored the vessel in Chicago. (2001-1-750.)

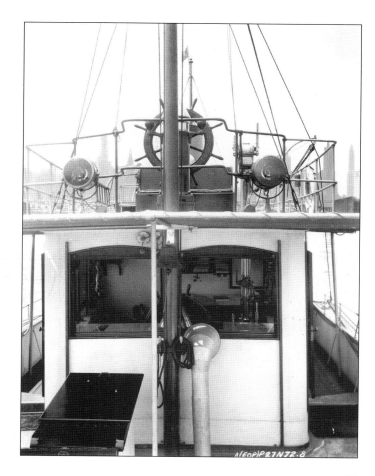

This photograph shows *Reality*'s pilothouse and flying bridge with the Chicago skyline in the background. (2001-1-753.)

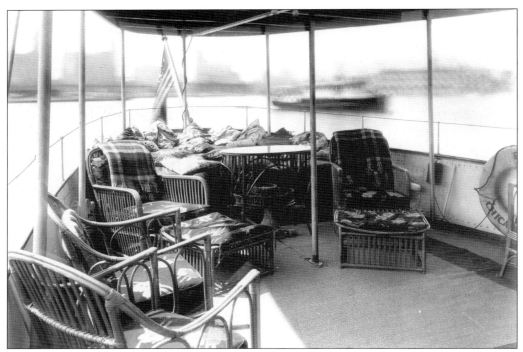

This image shows the afterdeck of *Reality*, which had a crew of two. The engine must be running because its vibration may be seen against the outside lake view. (2001-1-751.)

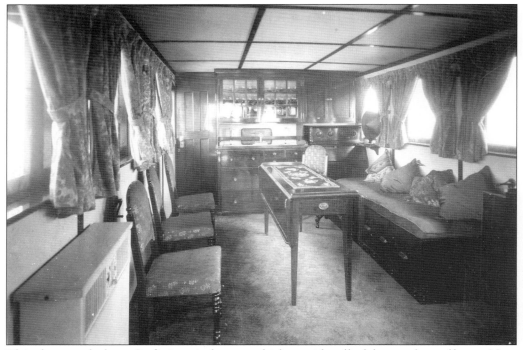

This photograph shows *Reality*'s main lounge, which provides all of the comforts of home. Note the early radio on the shelf to the right and its accompanying aerial. (2001-1-752.)

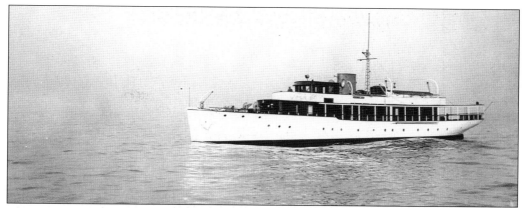

This 1930 photograph shows the 112-foot yacht *Northwind* (Hull 255) while underway. The yacht was built by the Manitowoc Shipbuilding Company for Charles Martin Clark Jr. of New York. Its beam was 22 feet, with a draft of 10 feet 9 inches and gross tonnage of 221. A crew of 11 operated it. (2001-1-199.)

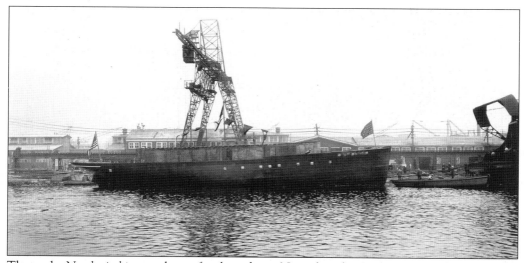

The yacht *Northwind* is seen here after launching. Note that the superstructure has none of its window and entry spaces cut into the deckhouse. Directly ahead of the *Northwind* may be seen the carferry *Pere Marquette 17*. (2001-1-488.)

Here is a shot of *Northwind* looking forward from the pilothouse. The canvas tarp covers an anchor windlass. Directly in front of the windlass can be seen the chain stoppers or "devil's claws," which hold the anchor chains and take the strain off of the windlass. (2001-1-469.)

This photograph shows *Northwind* looking forward from the stern of the top deck. The "anchor ball" raised up the mast indicates that the yacht is at anchor and not able to move under its own power. Note the motor launch that serves as *Northwind*'s tender. Shuffleboard anyone? (2001-1-470.)

This picture shows *Northwind*'s engine room. *Northwind* was equipped with twin 300-horsepower engines that were reversible and started with compressed air. Each control panel has an air pressure gauge, three cylinder pressure gauges, and a tachometer. The engine order telegraph or "Chadburn" may be seen in the center of the photograph. (2001-1-473.)

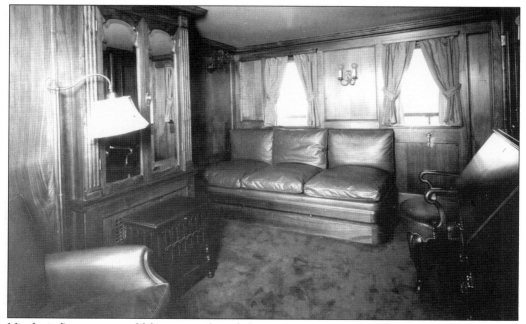

Northwind's owners could lounge on board the yacht, which required a crew of 11 to operate. Note the stove to provide heat when needed and the crank for raising and lowering the window. (2001-1-474.)

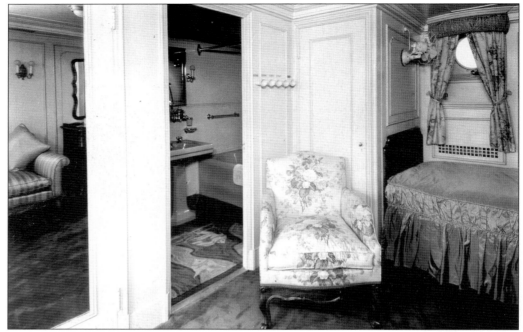

Pictured here is the yacht owners' stateroom on the *Northwind*. Note the voice tubes on the wall that communicate with the engine room, pilothouse, galley, captain's quarters, and maid service. (2001-1-475.)

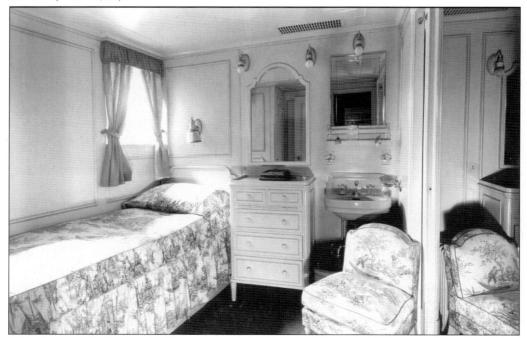

This photograph shows a double stateroom on board the *Northwind*. What appears to be a large mirror at the right of the picture proves to be a second stateroom with sliding doors to separate the two rooms if necessary. (2001-1-476.)

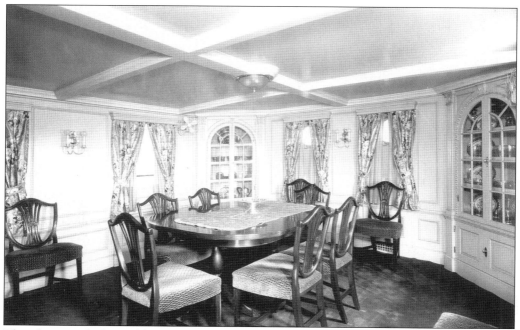

Northwind had a beam of 22 feet and a draft of over 10 feet. This bathroom was located in the lower hull of the yacht. Note the monogrammed towels. (2001-1-480.)

This photograph shows the main dining room on the 221-ton *Northwind*. The dining room was located at the forward end of the main deckhouse and boasted classic décor, electric fans, and cupboards containing all of the accoutrements for fine dining. (2001-1-482.)

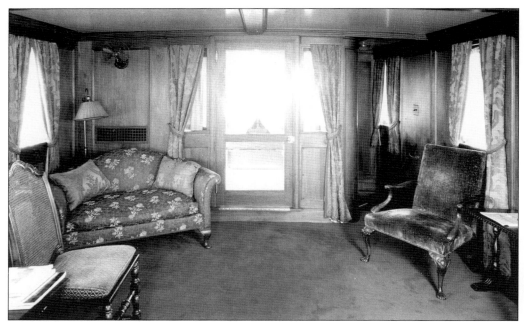

This perspective of the *Northwind* looks aft in the main lounge onto the after deck. Note the binnacle seen through the doorway, a stairway to the lower deck on the right, and a stairway on the left to the upper deck. (2001-1-483.)

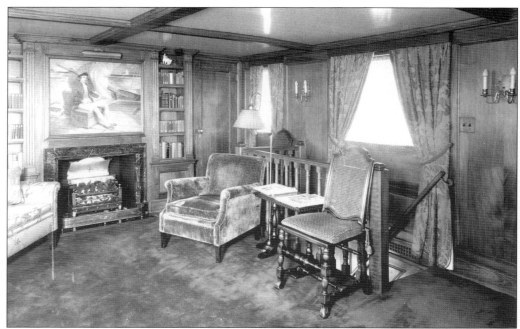

A shot looking forward at the library end of *Northwind*'s main lounge shows a stairway leading down to the stateroom area on the lower deck. The gas fireplace gives a comfortable feeling of hominess, while the library includes carefully selected volumes of current and classical literature. (2001-1-484.)

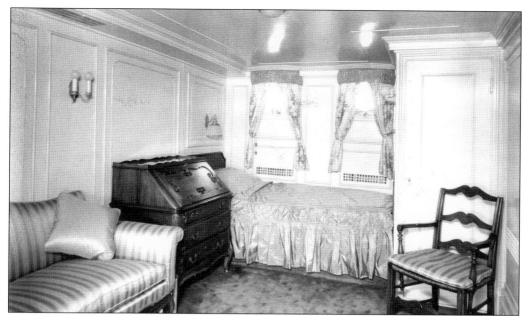

This picture shows another stateroom in *Northwind*'s lower hull. The furnishings provide for every need of the yacht guests including a bed, couch, closet, and a dresser with a writing desk on its top. (2001-1-486.)

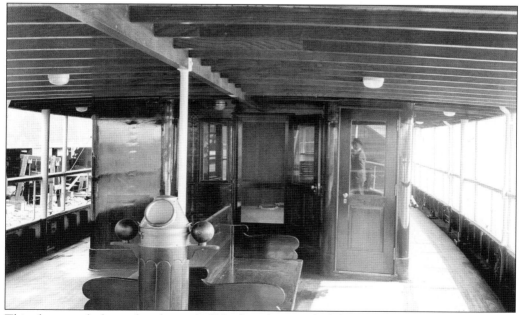

This photograph shows the after end of *Northwind*'s main deck looking forward. This picture was taken during the yacht's fitting out at the Manitowoc Shipbuilding Company. Note the lack of cushions on the benches beyond the ship's binnacle. The iron balls on either side of the binnacle were used to compensate for the magnetism of the steel ship's hull, so the compass would provide accurate readings. (2001-1-471.)

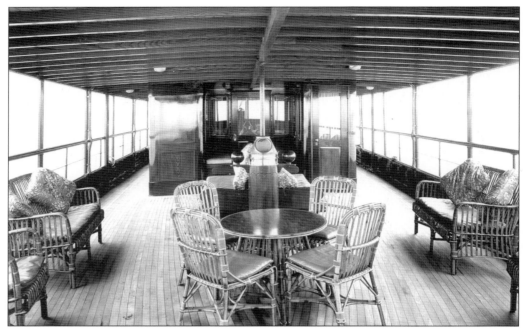

This image shows the yacht *Northwind* ready for delivery. This is the same scene as the previous photograph, but the yacht appears all dressed up and ready to go. The doorway on the right side of the deckhouse opens to a stairway that leads to the boat deck. (2001-1-471.)

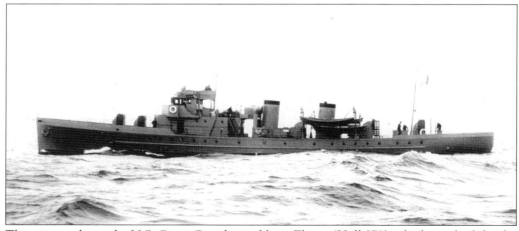

This picture shows the U.S. Coast Guard patrol boat *Electra* (Hull 278), which was built by the Manitowoc Shipbuilding Company and later became Franklin Delano Roosevelt's presidential yacht *Potomac*. The vessel was later bought by Elvis Presley and at one time in its career was owned by drug smugglers. It is now a National Historic Landmark and is open to the public at its dock in Oakland, California. (P82-378-1-25.)

Seven

SUBMARINES, LANDING CRAFT, AND MILITARY VESSELS

As it was in World War I, Manitowoc's shipbuilding contribution to World War II was monumental. Manitowoc's war effort began 15 months before Japan's December 7, 1941, attack on Pearl Harbor, Hawaii. Both the Manitowoc Shipbuilding Company and Burger Boat Company became deeply involved in building up the U.S. Navy's war fleet.

Manitowoc Shipbuilding Company's president, Charles West, had aspirations of building destroyers for the Navy Department, but the Navy Department asked him instead to build submarines. Initially, the Manitowoc Shipbuilding Company signed a contract to build 10 Gato-class submarines for $30 million. As the war progressed, other contracts were signed, resulting in the construction of 18 Balao-class submarines. Of the total 28 submarines built in Manitowoc, 25 of them saw action in World War II. The four Manitowoc submarines *Kete*, *Lagarto*, *Robalo*, and *Golet* were lost in action. The number of officers and enlisted men lost on these boats totaled 336. In addition to building submarines, the Manitowoc Shipbuilding Company also acquired military contracts to build 278 cranes, .50 caliber ammunition boxes, landing craft called LCTs, and a group of yard oilers.

The Burger Boat Company was also heavily involved in war production. It constructed 55 vessels, including wooden sub-chasers, minesweepers, rescue tugs, crash boats, and steel tugs for the U.S. Navy and U.S. Army.

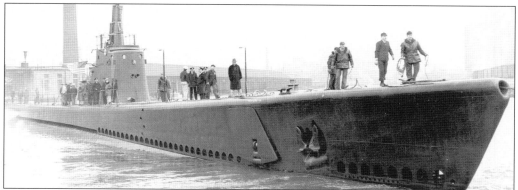

The *Peto* (SS-265) is returning to the Manitowoc Harbor after a trial run on Lake Michigan in 1942. *Peto* was the first submarine built at the Manitowoc Shipbuilding Company and lacked a gun emplacement on the forward end of the conning tower. Also seen in the photograph is the smokestack for the power plant of Northern Grain Elevator A. In the center of the photograph, the Soo Line Railroad warehouses and the Manitowoc County Courthouse, which remained in place in 2005, can be seen. (2001-1-1346.)

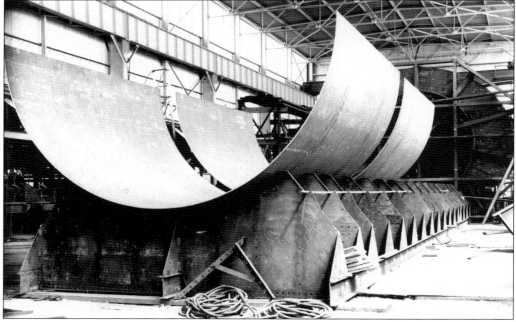

In 1941, the Manitowoc Shipbuilding Company's new hull shop was already rolling plates for the inner hull of the *Peto*. (2001-1-1492.)

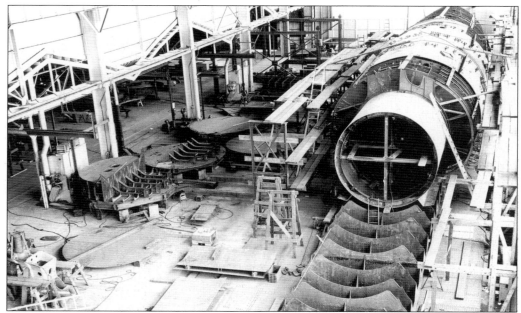

Peto's hull sections are photographed from the overhead crane at the Manitowoc Shipbuilding Company. To provide the best quality weld possible, hull sections were placed upside down on the jigs and welded. When finished, the hull section was turned upright and welding was completed. Also seen in the photograph is the fabrication of *Peto*'s bulkheads. The four bays on the left were constructed during World War I for building the Lakers. The hull shop, however, was added for the World War II submarine program. (2001-1-1496.)

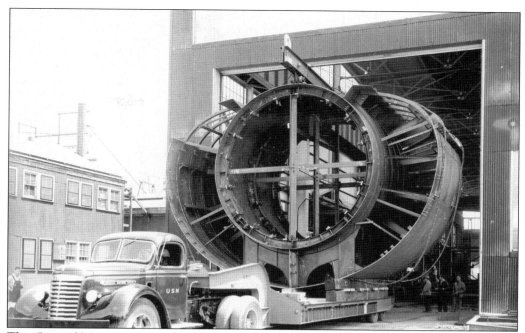

This General Motors tractor and a lowboy trailer are moving the first hull section of the *Peto* out of the hull shop. The section will be moved to Manitowoc Shipbuilding's Berth A. Once there, it will be placed on keel blocks by two specially designed cranes. (2001-1-1500.)

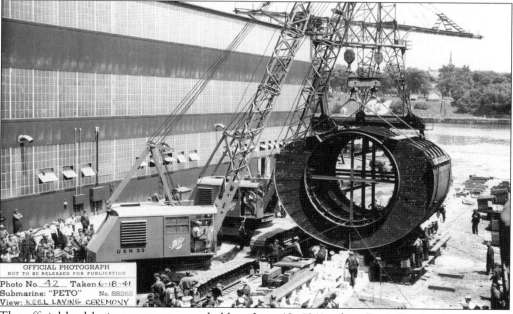

OFFICIAL PHOTOGRAPH
NOT TO BE RELEASED FOR PUBLICATION
Photo No. 42 Taken 6-18-41
Submarine: "PETO" No. SS265
View: KEEL LAYING CEREMONY

The official keel laying ceremony was held on June 18, 1941, when *Peto*'s Section J was placed on keel blocks. The two cranes, built by the shipyard specially for the job, worked so well that they became the basis for Manitowoc Company's Model 3900 Crane. This crane model would continue to be built by the Manitowoc Engineering Company for many years. While the 3900 is no longer in production, parts were still being sold as of 2005. (2001-1-1504.)

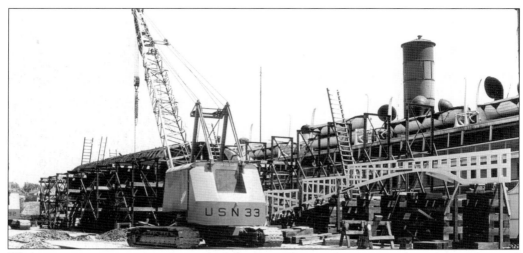

Work is progressing on the after end of the *Peto*. The wooden patterns have been fabricated to the exact contour of the keel of the *Peto*. The keel blocks are then laid to the precise height needed to support the sections. The steamer *Theodore Roosevelt* has been placed alongside Berth A to hide the construction of the *Peto*. Security was of utmost importance in the early stages of the war effort. (2001-1-1511.)

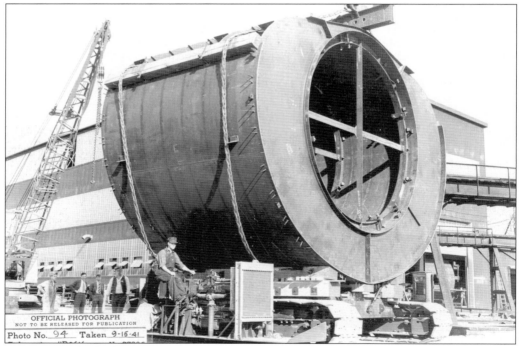

OFFICIAL PHOTOGRAPH
NOT TO BE RELEASED FOR PUBLICATION
Photo No. 94 Taken 9-15-41

Manitowoc Shipbuilding Company workers constructed this crawler transport to move large subsections of the submarine to their proper location. Overcoming construction obstacles was a common occurrence in building the Manitowoc submarines. Many of these innovative construction practices would be used long after the submarine program was over. The crawler transport was still being used in 2005 to move heavy equipment at Manitowoc Company's Bay Shipbuilding facility in Sturgeon Bay, Wisconsin. (2001-1-1602.)

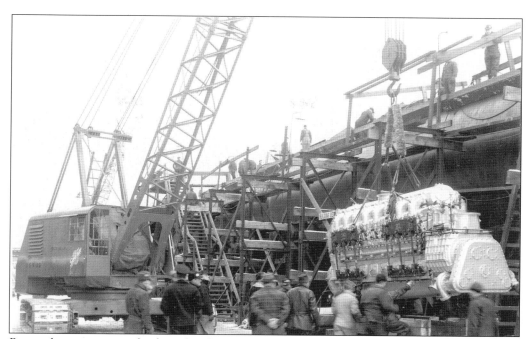

Peto is about to receive the first of its four General Motors V-16 engines. These 1,600 horsepower General Motors diesels served as the standard engine for marine applications as well as for railroad locomotives. Prior to installation on board a submarine, all internal machinery and equipment was weighed to certify the total weight of a submarine before completion. (2001-1-1529.)

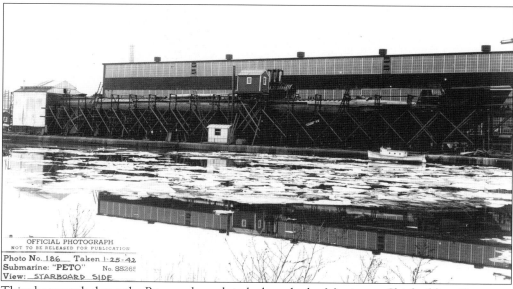

This photograph shows the *Peto* nearly ready to be launched at Manitowoc Shipbuilding Company. It also shows that the pressure hull of the conning tower has been installed, however, the outer skin of the conning tower has not been installed. On the deck of *Peto* a small house used to secure the blueprints for the submarine construction may be seen. The house was removed before launching the submarine and relocated to the next submarine ready for construction. (2001-1-1530.)

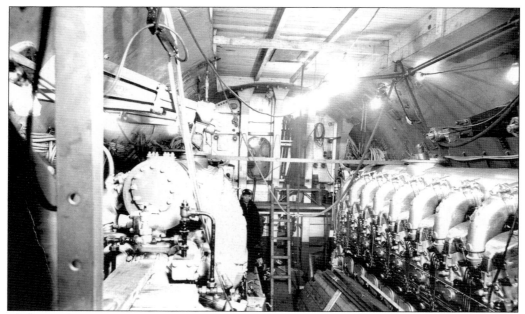

The *Peto's* forward engine room shows that the top of the pressure hull has not yet been welded in place. A temporary wooden ceiling has been built in its place. (2001-1-1533.)

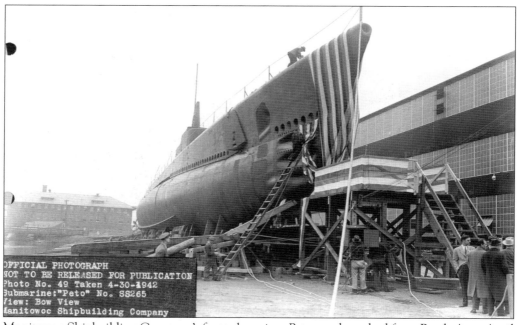

OFFICIAL PHOTOGRAPH
NOT TO BE RELEASED FOR PUBLICATION
Photo No. 49 Taken 4-30-1942
Submarine:"Peto" No. SS265
View: Bow View
Manitowoc Shipbuilding Company

Manitowoc Shipbuilding Company's first submarine, *Peto*, was launched from Berth A on April 30, 1942. The photograph shows *Peto's* bow and launching platform bedecked with bunting. During a normal launch, a large crowd of spectators lined the banks on both sides of the Manitowoc River. Even local schoolchildren were dismissed from school so that they could view the launch. The shipyard administration building is shown on the picture's left and the hull shop is on the right. (2001-1-1543.)

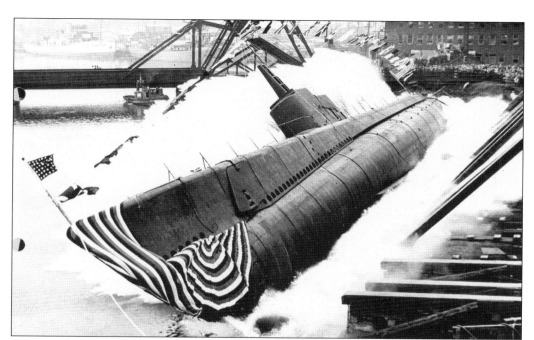

The tug *Emil A. Weber*, owned by Manitowoc's McMullen and Pitz Company, stands ready to assist the *Peto* after its launch. The white-hulled U.S. Coast Guard cutter *Escanaba* can be seen beyond the railroad bridge. Side-launching was commonplace among Great Lakes shipbuilders, but the navy viewed the practice of side-launching submarines with great skepticism and many naval authorities considered the practice dangerous and undignified. After the launch of *Peto*, side-launching became an accepted practice by the U.S. Navy. (2001-1-1549.)

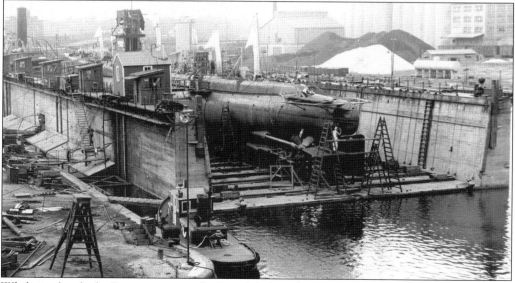

While in dry dock, *Peto* receives its final work below the waterline before commencing its sea trials. The tug *Manshipco*, owned by the Manitowoc Shipbuilding Company, is moored at the end of the dry dock. Manitowoc's Portland Cement Company plant can be seen on the opposite bank of the Manitowoc River. (2001-1-1556.)

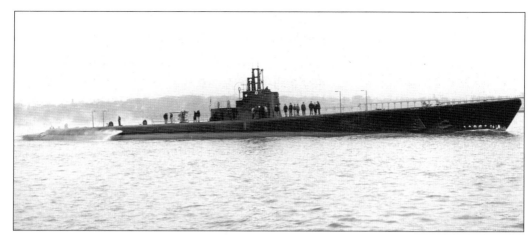

The *Peto* is shown leaving Manitowoc Harbor to commence its first sea trial on Lake Michigan. *Peto* was the first of 28 submarines to be built by the Manitowoc Shipbuilding Company. Manitowoc-built submarines sank over 500,000 tons of enemy shipping during World War II. (2001-1-1578.)

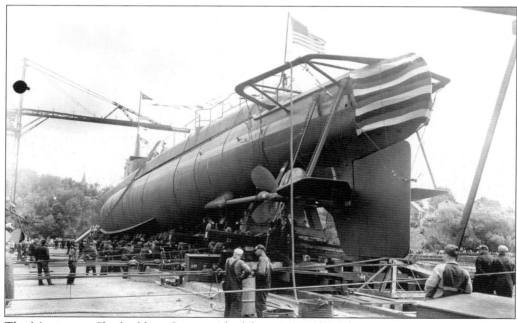

The Manitowoc Shipbuilding Company had five separate launching ways set up for submarine construction, so it could work on five submarines simultaneously. In this 1942 photograph, the submarine *Pogy* can be seen being readied for launch on Berth B-1 and the weight of the sub has been transferred from its keel blocks to the launching skids. At this stage in the process, thick rope lines are all that holds the submarine in place. Zinc plates can be seen on the struts supporting the propeller shaft. They act as a sacrificial metal to prevent corrosion around the propeller area. (2001-1-1541.)

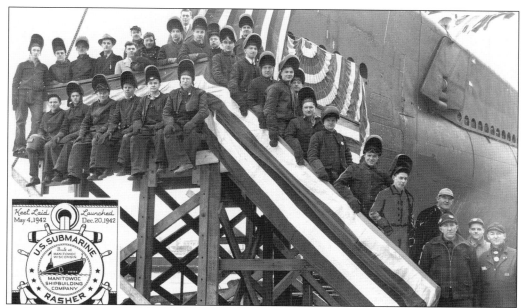

In this 1942 photograph, the *Rasher* (SS-269) can be seen with numerous women welders on its launch platform. Women were thought to be very adept at fine hand control, which is essential for a strong weld. During its service in the Pacific Theater, the *Rasher* accumulated an impressive battle record by sinking 18 enemy vessels for a total of 99,901 tons of enemy shipping. *Rasher*'s record of enemy vessels sunk and total tonnage was the highest of all 28 submarines built by the Manitowoc Shipbuilding Company. Of the 288 American submarines that served in World War II, *Rasher*'s record was superseded by only one other submarine. That submarine was the USS *Flasher*, which sank 21 vessels for a combined total of 100,231 tons. (2001-1-1455.)

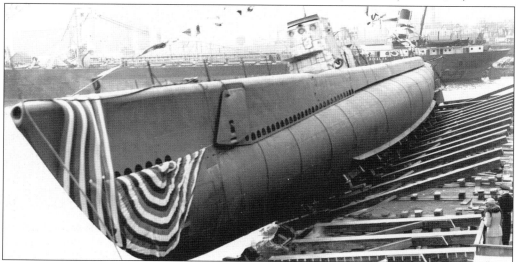

The *Rasher* was launched from Manitowoc Shipbuilding's Berth B-1 in 1943. The Boland and Cornelius Company's self-unloader cargo-vessel *Sinaloa* can be seen across the Manitowoc River. Prior to its involvement in submarine construction, the Manitowoc Shipbuilding Company converted the *Sinaloa* from a self-unloading sand sucker to a self-unloading bulk freighter. (2001-1-1885.)

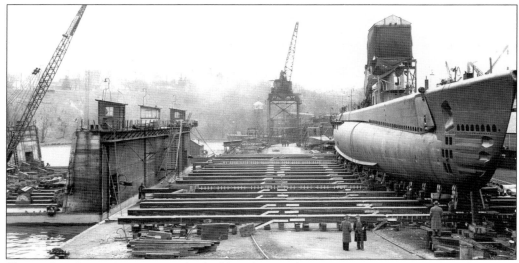

Shipyard workers at Manitowoc Shipbuilding frequently overcame construction obstacles in the submarine building program. In Berth D, rails of a McMyler gantry crane were located too close to the edge of the Manitowoc River, so the berth had to be moved inboard of the crane rails. When a submarine was ready for launch, it had to be slid sideways to the river's edge by the crane in the dry dock before the launching skids could be fitted. In this 1943 photograph, the *Robalo* is ready to be moved to the river's edge while the hull of the *Rasher* can be seen in the river, fitting out alongside Berth C. (2001-1-1899.)

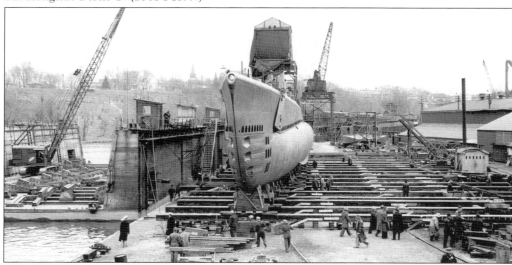

This photograph shows the *Robalo* in launch position with the skids ready to be set up. The dry dock section will be moved to allow room for the launch. Behind the *Robalo* sits the submarine *Golet* in Berth C. The *Robalo* and *Golet* were two of the four Manitowoc-built submarines lost in combat during World War II. The other two submarines lost during World War II were the *Kete* and *Lagarto*. The inner conning tower is in place, and the outer conning tower has yet to be attached. A partially completed landing craft tank, or LCT, is also in the photograph. Manitowoc Shipbuilding Company built the original model of the LCT 6, which was mass-produced at eight locations throughout the United States. LCTs were used in amphibious landings in North Africa, Sicily, Normandy, and the Pacific during World War II. (2001-1-1905.)

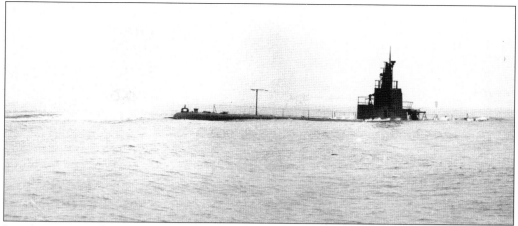

In this 1943 photograph, the *Raton* is shown undergoing diving trials on Lake Michigan. (2001-1-1842.)

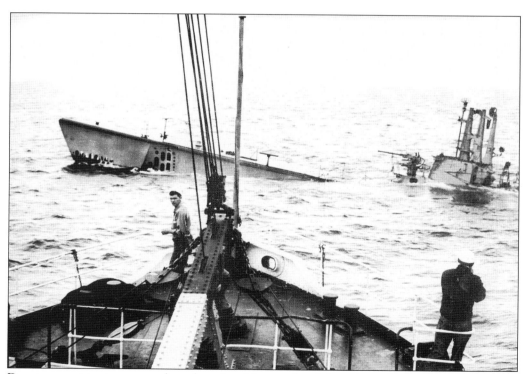

Due to a positioning error, the submarine *Mero* surfaced directly in front of USS *Tamarack*, which was underway at the time. Evasive maneuvering by the skipper and crew of the *Tamarack* prevented a fatal collision. *Tamarack* was used as a tender for sea trials of all the submarines. (P81-43-1-104.)

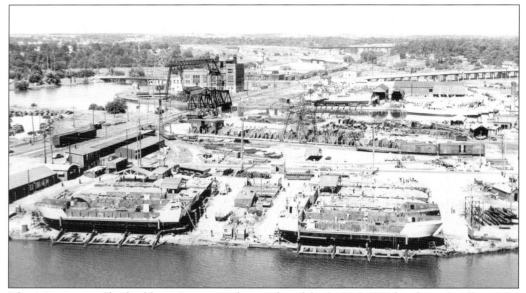

The Manitowoc Shipbuilding Company designed and built 36 LCTs for the war effort. The LCTs could carry five medium tanks to a beach and land them from the bow door, which served as a ramp when lowered. Shown in this 1942 photograph are eight LCTs in various stages of construction. In the background, Burger Boat Company can be seen building and fitting out patrol craft and minesweepers. (2001-1-2000.)

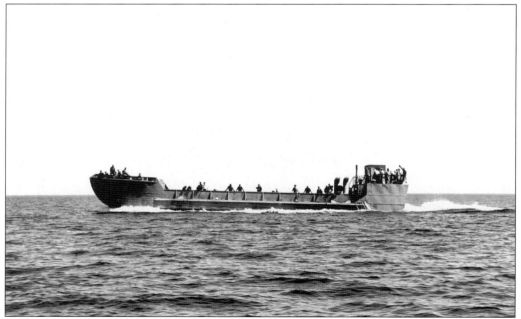

This 1942 photograph shows a port side view of the first sea trial of *LCT-13* on a northbound run. (2001-1-2004.)

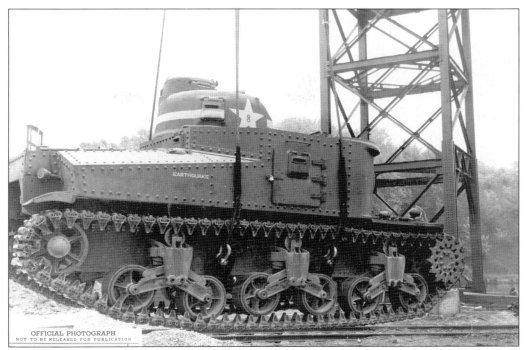

The U.S. Army furnished the Manitowoc Shipbuilding Company with five M-3 Grant tanks for testing LCTs. While the Grant tank was suitable for testing LCTs, it did have a few drawbacks in combat situations. The three-inch gun was side mounted on the tank body and not on the tank turret, so the tank had to face the target in order to aim its gun. In addition, the riveted hull was much easier to penetrate than the later cast steel hulls. (2001-1-2005.)

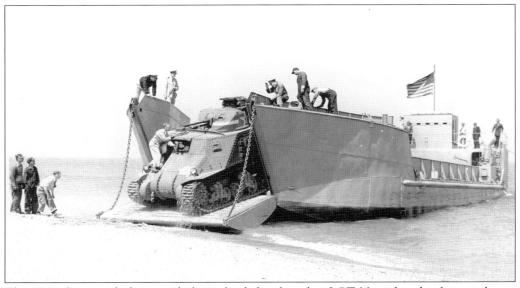

This 1942 photograph shows tanks being loaded on board an LCT. Note that the three-inch gun is missing from the tank's side mount where the soldier is standing. (2001-1-2006.)

Shown in this 1942 photograph is the crew's quarters and the galley on board an LCT. When fully staffed an LCT had a crew of 21. (2001-1-2022.)

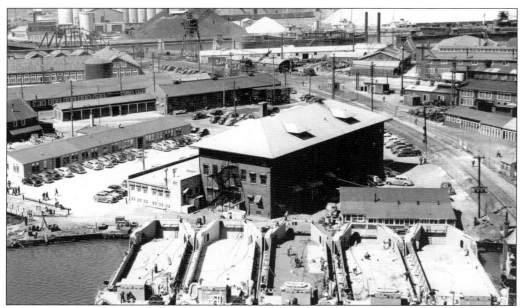

Five LCTs are being fitted out in 1942 near the Manitowoc Shipbuilding Company's administration building. Each LCT held up to five tanks. Also shown in the photograph is the gate of the original graving dock at the Manitowoc Shipbuilding Company. The graving dock was filled in and used as a parking lot. The submarine *Peto* is also seen sitting in the dry dock in the background. The early submarines encountered a serious vibrating noise in their hollow propeller shafts. To counter the problem, Manitowoc Shipbuilding filled *Peto*'s shafts with bb shot. As other submarines were built their propeller shafts were filled with sand. The cement boat *Daniel McCool* can also be seen at the Portland Cement Company dock and an unidentified deep-water tug is also in the photograph. (2001-1-2027.)

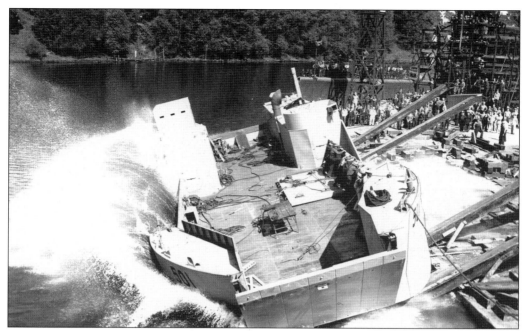

The design of the LCT-5s was improved to develop an LCT-6 design. The U.S. Navy designated the one built at Manitowoc as *LCT 501*. It was launched in 1943 from the east end of Berth D at the Manitowoc Shipbuilding Company. Behind this LCT is the submarine *Rasher*, while the bow of the submarine *Golet* can also be seen. The *Rasher* went on to distinguish itself in World War II, and the *Golet* was lost in action. (2001-1-2028.)

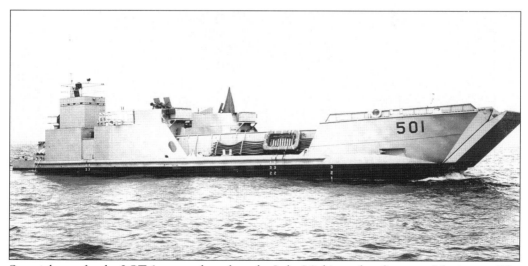

Sea trial runs for the *LCT-6* are conducted on the Lake Michigan shoreline near Manitowoc. The landing craft was fitted with two twin 20 millimeter guns for anti-aircraft protection. (2001-1-2029.)

The design of the *LCT-6* proved to be very versatile. In addition to landing troops and vehicles, the landing craft could fire rocket launchers to blanket the landing beaches with rocket fire. (2001-1-2032.)

Both the LCT-5s and LCT-6s were designed and built in three separate floatable sections for ease of transportation to the theater of operations. Once they arrived at that location, they could be placed in the water and assembled. This 1943 photograph shows a landing craft being tested. (2001-1-2066.)

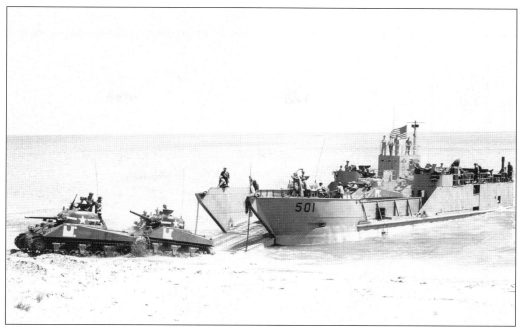

Rawley Point, located just north of Two Rivers, Wisconsin, became the site for testing the *LCT*-6. The tanks being used in this test are Sherman M-4s. (2001-1-2050.)

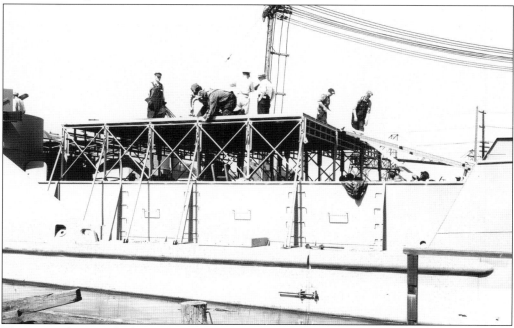

This 1943 photograph shows the new *LCT*-6 design with a top deck or "flight deck" as it was sometimes called. The extra deck increased the amount of carrying capacity of the landing craft, so that trucks could be loaded and off-loaded from the top deck. Once the Manitowoc Shipbuilding Company had tested the LTC-6 design, its blueprints were forwarded to many manufacturing plants throughout the United States for production. (2001-1-2060.)

Frances Pitz was selected to sponsor *Yard Oiler No. 202*. She was the wife of Armin L. Pitz, who served as hull superintendent at the Manitowoc Shipbuilding Company. To ensure that the bottle of champagne shattered at the christening, a section of angle iron was mounted on the hull at the five-foot draft mark. As the champagne bottle hit the angle iron, it smashed and the yard oiler was christened. (2001-1-2096.)

Manitowoc Shipbuilding's hull superintendent Armin L. Pitz awaits the signal to operate a guillotine, which will cut the holding ropes. Once the ropes are cut, the vessel is free to slide into the water. Shipyard workers can be seen in the background. (2001-1-2099.)

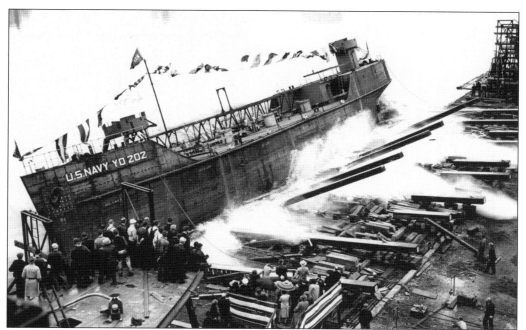

This 1945 photograph shows *Yard Oiler No. 202* hitting the water at Berth B-1 at the Manitowoc Shipbuilding Company. (2001-1-2101.)

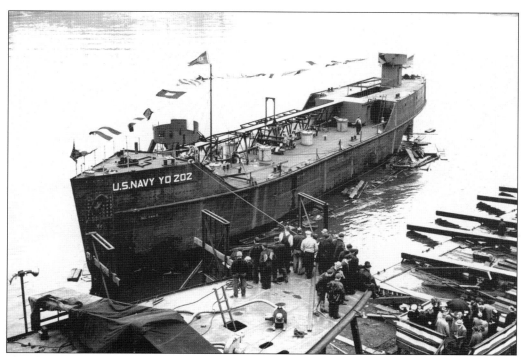

Shortly after launching, the U.S. Navy's *Yard Oiler No. 202* can be seen at its launch site in the Manitowoc River. (2001-1-2102.)

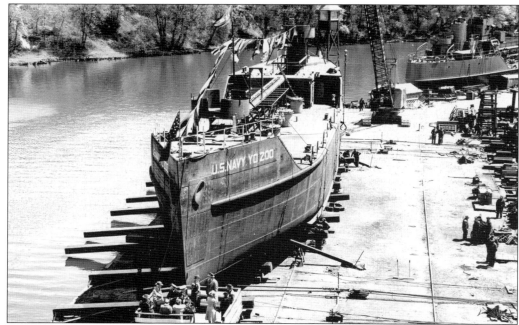

Yard Oiler No. 200 is shown in Manitowoc Shipbuilding's Berth D ready to be launched. This yard oiler, like the submarine *Robalo*, had to be built to the right of the gantry crane tracks and slid across to the launching position. This photograph also shows a nearly finished yard oiler, and a guard tower can be seen directly behind the yard oiler. Military guards were stationed in the guardhouse 24 hours per day. On some dark nights, local pranksters would throw stones in the river near the yard oilers. The guards would turn on a searchlight to find the source of the splash made by the thrown rocks. (2001-1-2086.)

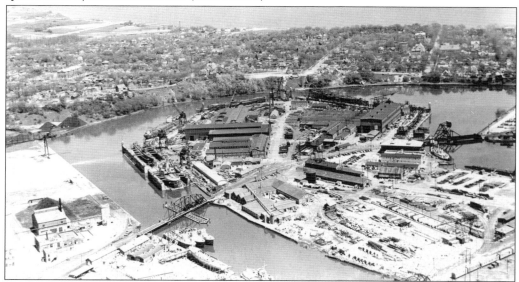

The Manitowoc Shipbuilding Company and Burger Boat Company are shown in this 1943 photograph. Both of the yards were heavily involved in the war effort at the time this photograph was taken. (P95-8-12.)

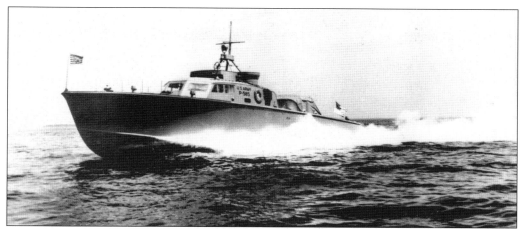

Speed trials were conducted on Lake Michigan for this 85-foot Burger-built U.S. Army aircraft search and rescue boat. This port side photograph was taken in 1944. (P86-5-2.)

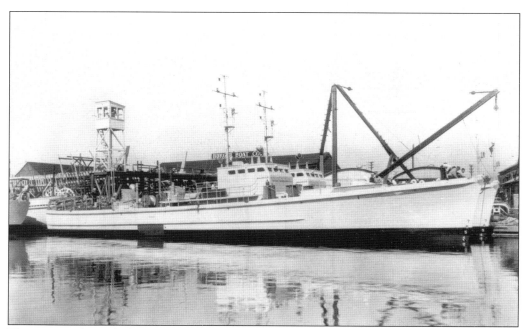

The two 110-foot sub-chasers, shown in this 1942 photograph, were built at the Burger Boat Yard at Manitowoc. These sub-chasers are nearly ready for their sea trials. (P69-4-6.)

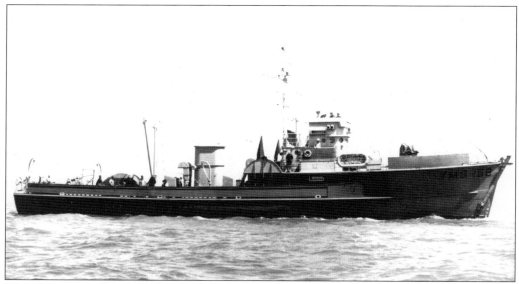

This photograph shows a U.S. Navy yard minesweeper on sea trials in Lake Michigan. It was one of the 14 yard minesweepers that Burger Boat Company built during World War II. The length of time from keel laying of a yard minesweeper to delivery of the vessel in New Orleans was nine months. (P69-4-9.)

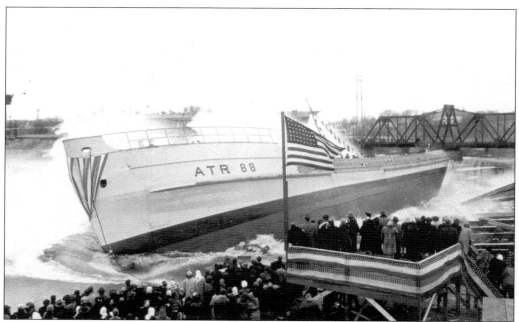

This 1944 photograph shows the seagoing rescue tug *ATR-88*. Two of these 165-foot seagoing tugs were built at Burger Boat Company for the war effort. (P69-4-21.)

Eight

A SAMPLING OF MANITOWOC MARITIME SCENES

Shipbuilding in Manitowoc has always been part of the maritime history of the city. However, it is likely that more money was made in ship repair and conversions because new construction was always a feast-or-famine situation. Whether the shipyards were busy or not, the day-to-day business of shipping in and out of Manitowoc continued and the city continued to prosper. After the centennial of the first vessel built in Manitowoc, the shipbuilding and shipping industries continued for a few decades until Great Lakes vessel designs grew too large to navigate the tight curves in the Manitowoc River and local industry that relied on shipping died out. In 2005, shipping into Manitowoc consisted of coal for the local power plant, loads of cement for local construction needs, and the summer-time operation of the passenger and automobile ferry SS *Badger*. The photographs in this chapter depict typical scenes of maritime Manitowoc over the years.

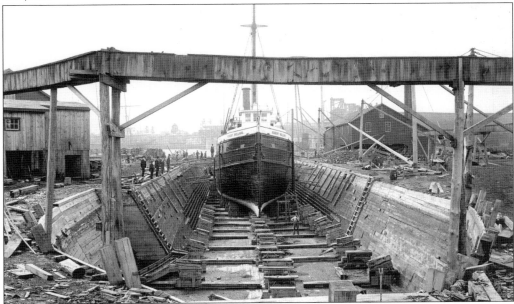

The wooden steamer *Robert Holland* is seen in the graving dock at the Burger and Burger Shipyard in 1897. The graving dock became part of the Manitowoc Shipbuilding Company when Burger was sold to the organization. The overhead structure carries steam pipes from the powerhouse on the right of the photograph to buildings on the left. (P82-37-7-84.)

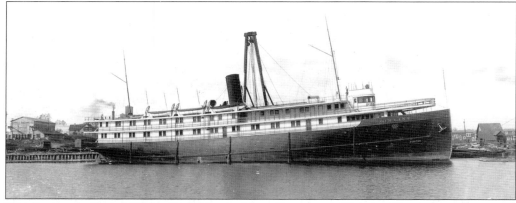

The *Puritan*, built in 1901 by Craig Shipbuilding Company of Toledo, Ohio, was to be named *Ottawa*; however, it was bought by Graham and Morton Transportation Company before completion and named *Puritan*. It is shown tied up at Manitowoc before going into the graving dock where it was cut in two and lengthened by 26 feet. (P82-37-7-39.)

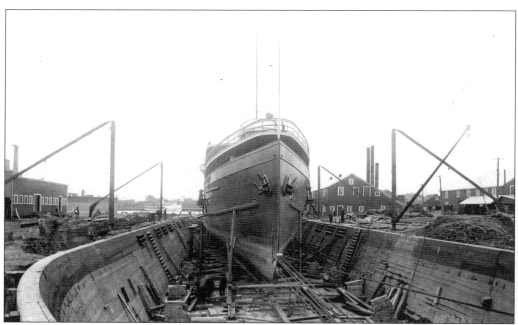

The *Puritan* is seen in the graving dock all set up for lengthening. It has been cut apart and has heavy block and tackles attached to the bow for pulling it forward. Note the difference in the graving dock when compared to the previous photograph on page 121 showing the *Robert Holland*. (2001-1-691.)

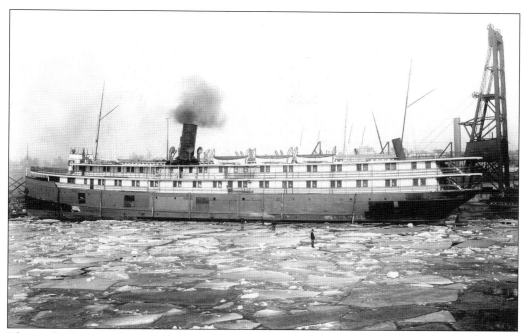

This is the *Puritan* after adding 26 feet behind the stack. It is under steam and has just backed out of the graving dock and is situated across the Manitowoc River just below the Soo Line Railroad's lift bridge. A closer inspection shows temporary handrails on the new 26-foot section. The boys standing on the ice are showing less-than-good judgment. (2001-1-65.)

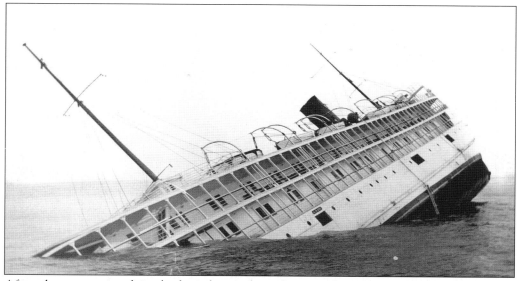

After a long career involving both civilian and naval service, *Puritan* was rebuilt once again and renamed the *George M. Cox* to serve the Isle Royal Transportation Company. While steaming from Houghton, Michigan, to Port Arthur, Canada, on its maiden voyage as the *Cox*, it ran onto Lake Superior's Rock of Ages Reef in a heavy fog at 17 knots. Although no lives were lost, the ship was a total loss. A storm arose shortly after this photograph was taken and the *Cox* slid off of the reef into deep water where its wreck still lies. (P82-37-2-3.)

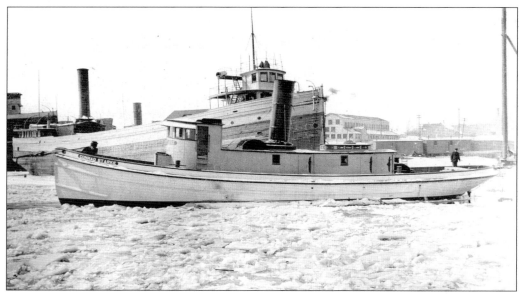

Manitowoc Shipbuilding constructed the tug *Conrad Starke* (Hull 56) in 1912. It is shown here rounding the bend in the ice-filled Manitowoc River, past an unidentified wooden freighter tied up at Berth G, on its way toward the Tenth Street Bridge. (P82-37-9-17.)

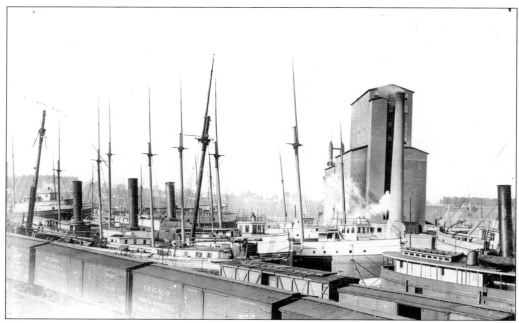

The winter fleet is tied up on the south side of the Manitowoc River above the Tenth Street Bridge. Directly beneath Elevator A is the *Charles A. Eddy*. Located against the riverbank on the left is the *W. S. Crosthwaite*. The outboard vessel on the far left is the *John Craig*. Across the river can be seen the newly constructed Soo Line Railroad's warehouse, which was located just upstream from the Soo Line's carferry slip. (P82-37-9-292.)

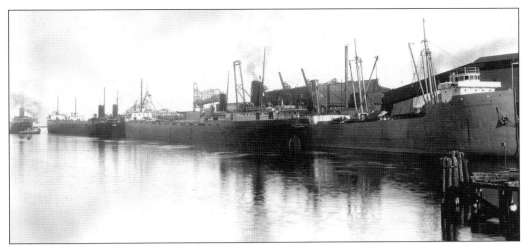

Part of the 1933–1934 winter fleet preparing to depart for the upcoming season is seen here. Four Reiss Steamship Company vessels, including the *J. L. Reiss* and *Clemens A. Reiss* are docked east of the Eighth Street Bridge, along with the cement carrier *Westoil*. Another Reiss boat is visible at the far left with the Reiss Coal Company tug *Green Bay* at the stern. (P82-37-9-65.)

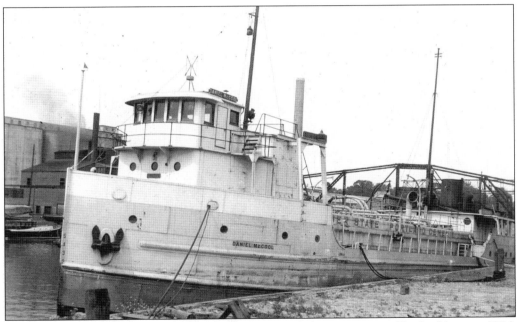

The cement boat *Daniel McCool* (Hull 223) was built by Manitowoc Shipbuilding in 1926. Although listed as a steamer, it was diesel powered. It is shown here tied up at the Manitowoc Shipyard above the Soo Line Railroad swing bridge and directly across from the Burger Shipyard. The Badger State Cement plant can be seen in the background. By 1958, the *McCool's* name was changed to the *J. B. John*. It sat at the cement plant for a few years, but by 1960 it left Manitowoc for good. (P82-37-3-38.)

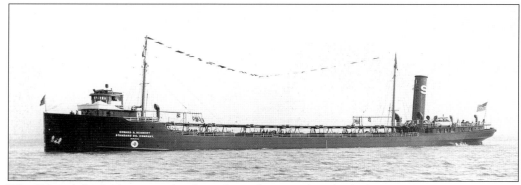

The *Edward G. Seubert* was the first of two large tankers built for Standard Oil Co. It was launched in July 1930, and it was later renamed *Amoco Wisconsin*. The vessel was powered by one of the last triple-expansion steam engines built by the Manitowoc Shipbuilding Company. (P82-37-2-40.)

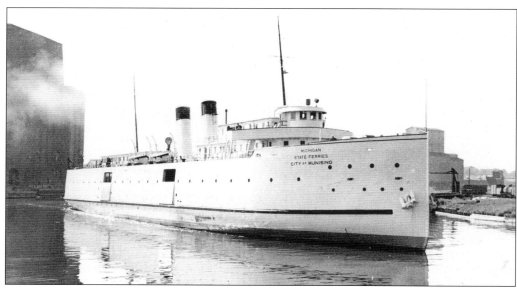

The carferry *Pere Marquette 20* is shown here after its 1938 conversion to an automobile ferry for the Michigan State Highway. It became the *City of Munising* and steamed across the Straits of Mackinac, and it was later modified to load and unload vehicles from bow and stern. (P82-37-1-48.)

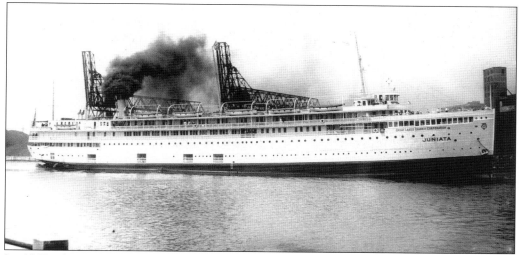

In 1940, the steamer *Juniata* got a new lease on life when the Manitowoc Shipbuilding Company converted it into the SS *Milwaukee Clipper*. It was built in 1905 along with sister ships *Octorora* and *Tionesta*. After operating for many years as a cross-lake passenger carrier, the *Milwaukee Clipper* was finally laid up and is now a museum ship and National Historic Landmark in Muskegon, Michigan. The *Clipper's* massive quadruple-expansion steam engine is one of only two still in existence on the Great Lakes and when in operation could develop about 3,000 horsepower. (P82-37-3-95.)

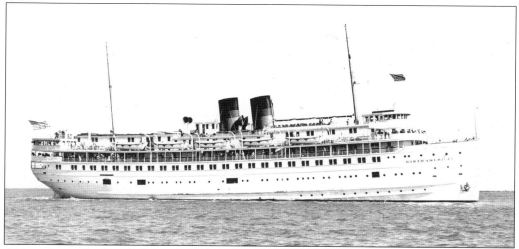

Although not built in Manitowoc, the Georgian Bay Line passenger vessel *North American* (shown here) and its sister ship *South American* were frequent visitors to Manitowoc Shipbuilding Company's shipyard for dry-docking or other repair work. The *North American* steamed on the Great Lakes until 1963 when it was sold. In 1967, it sank in the Atlantic while being towed to another destination. The *South American* also left the Great Lakes in 1967 and became a floating classroom on the East Coast. (P82-37-11-130.)

Suggested Reading

Chavez, Art. *S.S. Badger: The Lake Michigan Carferry*. Chicago, IL: Arcadia Publishing Company, 2003.

Chavez, Art. *S.S. City of Midland 41*. Chicago, IL: Arcadia Publishing Company, 2004.

Dowling, Rev. Edward J. *Know Your Lakers of World War I*. Sault Ste. Marie, MI: Marine Publishing Company, 1978.

Elliott, James L. *Red Stacks over the Horizon*. Grand Rapids, MI: William B. Erdmann Publishing Company, 1967.

Fredrickson, Arthur C. and Lucy F. *History of the Ann Arbor Auto and Train Ferries*. Frankfort MI: Gulls Nest Publishing, 1994.

Fredrickson, Arthur C. and Lucy F. *Pictorial History of the C and O Train and Auto Ferries and Pere Marquette Line Steamers*. Ludington, MI: Lakeside Printing Company, 1965.

Hilton, George W. *The Great Lakes Carferries*. Berkeley, CA: Howell North, 1962.

Nelson, William T. *Fresh Water Submarines: The Manitowoc Story*. Manitowoc, WI: Hoeffner Printing, 1986.

Peterson, Paul S., et al. *Ludington's Carferries: The Rise, Decline and Rebirth of a Great Lakes Fleet*. Ludington, MI: Ludington Daily News, 1997.